drawing cute

with Katie Cook

200+ Lessons for Drawing Super Adorable Stuff

This is a super-serious* art book.

*No, it isn't. It's fun and weird . . . and fun and
weird is what you need more of in your life.

xo, Katie

IMPACT
CINCINNATI, OHIO
IMPACTUniverse.com

Contents

chapter 1

ANIMALS . . . 6

Farm Animals, Pets, Sea Life, Woodland Creatures, Bugs, Jungle Animals, Other

chapter 2

FOOD STUFF . . . 40

Desserts, Drinks, Fruits and Vegetables, Meals, Other

chapter 3

HOBBIES AND SPORTS . . . 68

Art, Musical Instruments, Sports, Outdoor Activities, Gaming

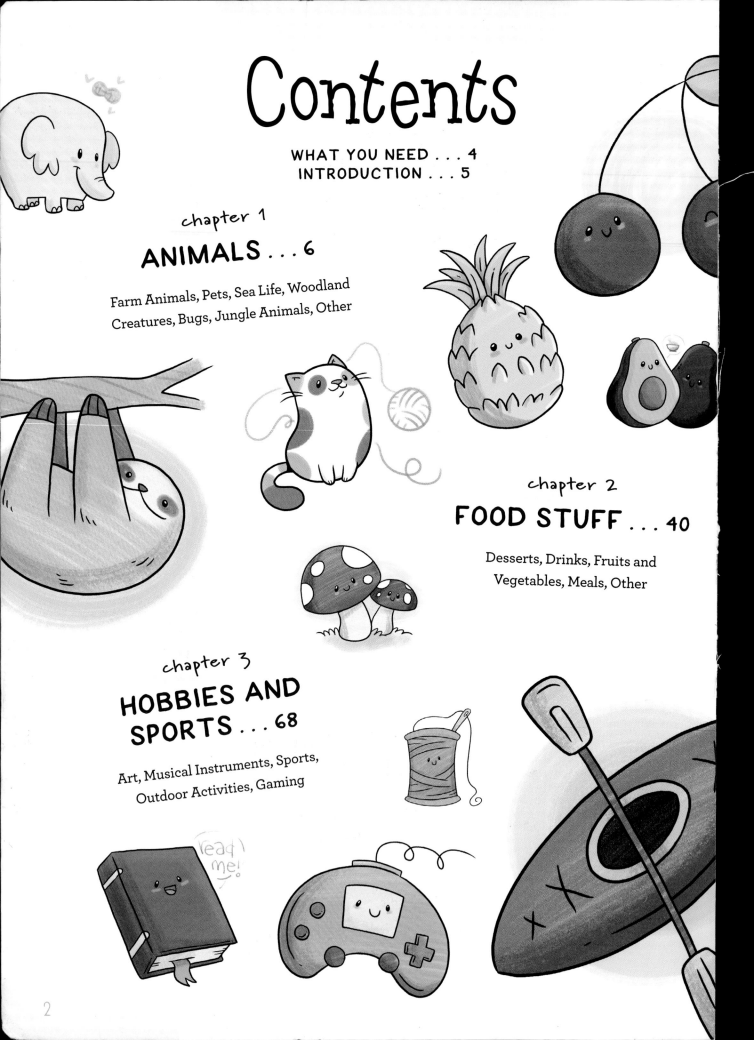

read me!

chapter 4
HOLIDAYS AND SEASONS . . . 86

Winter, Spring, Summer, Fall

chapter 5
HANDY DANDY OBJECTS . . . 106

Electronics, Household
Items, Useful Tools

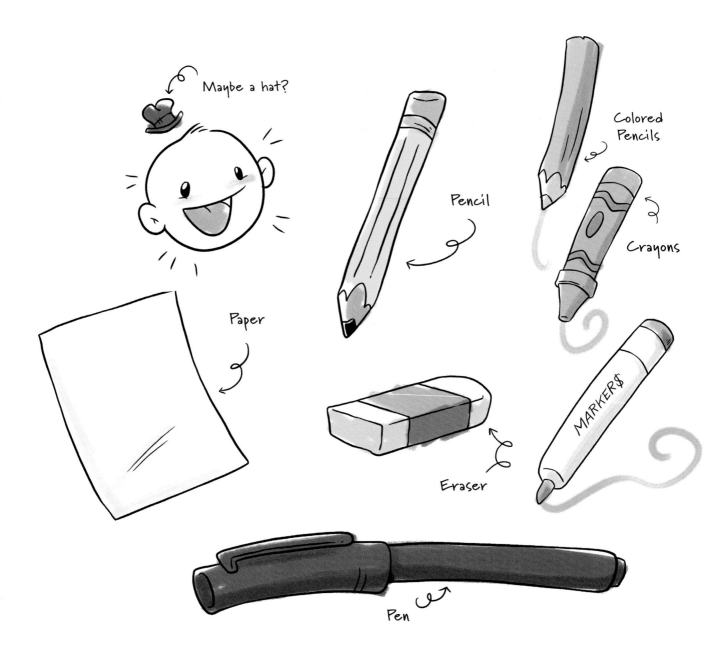

What You Need

A positive attitude and a sense of humor (cannot be bought)

Paper, I guess. Walls probably are not a good idea unless you are SUPER COMMITTED.

Pencils

An eraser because we all make mistakes.

A good ol' black ink pen or marker

Something to color with . . . crayons, markers, colored pencils, watercolors . . . dealer's choice

Introduction

I hope you know what you've gotten yourself into with buying this book. I really do.

In the words of my favorite college professor, Mike Mikos, "Drawing is better than eating peanuts." I took this to mean drawing is fun, salty, delicious and the best thing ever as long as you don't have a peanut allergy.

If you really want to get technical, I would suggest drawing lightly in pencil *first* and going over your drawing with your pen . . . then erase your pencil lines and color.

Or, if you want to just jump in and doodle away, go for it. I'm just offering up a guideline of how to draw these things; change things up and make them your own. Add cat ears to broccoli, put sunglasses on the sloth, draw your *own* how-to lessons with crazy text and send them to me.

See?

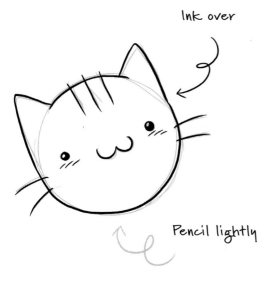

Ink over

Pencil lightly

Mostly, the main goal here is to have fun and learn how to draw a potato. That lesson is really the only reason I wanted to do this book. If you know how to draw a potato, the art world is an open door.

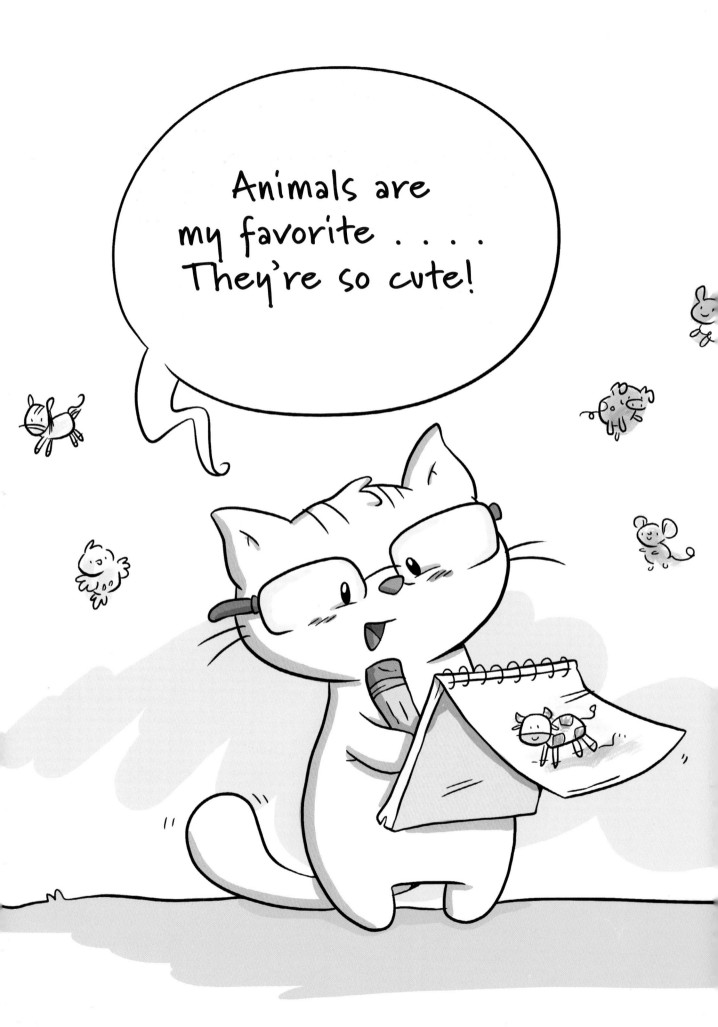

CHAPTER 1
Animals

Who doesn't love animals? I mean, there's probably someone out there who truly doesn't like cats, but you can't trust that person.

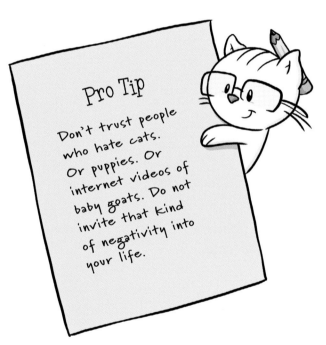

Pro Tip

Don't trust people who hate cats. Or puppies. Or internet videos of baby goats. Do not invite that kind of negativity into your life.

Chicken

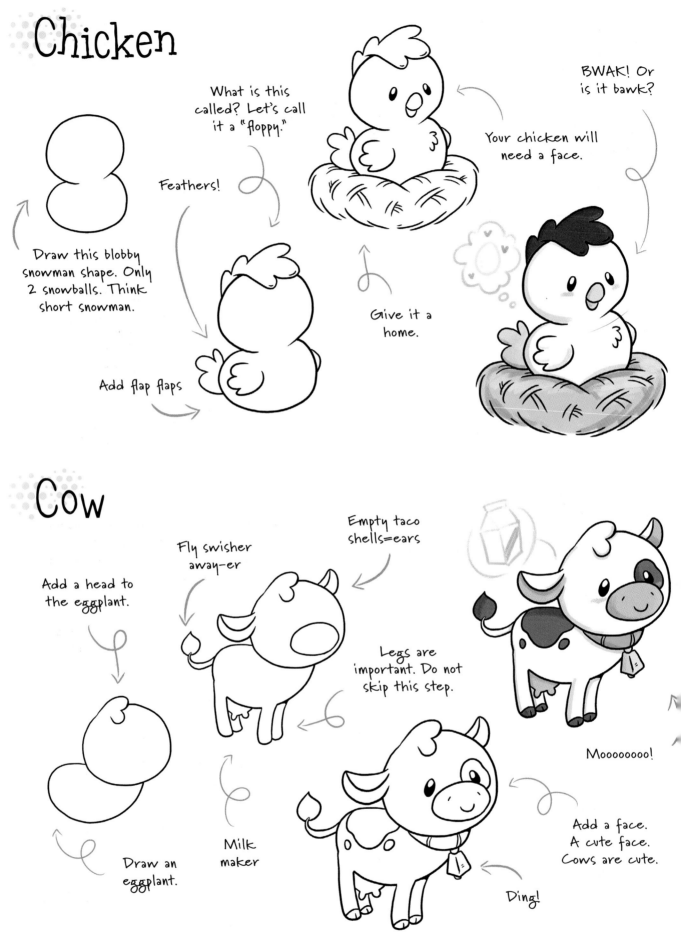

Draw this blobby snowman shape. Only 2 snowballs. Think short snowman.

What is this called? Let's call it a "floppy."

Feathers!

Add flap flaps

BWAK! Or is it bawk?

Your chicken will need a face.

Give it a home.

Cow

Add a head to the eggplant.

Fly swisher away-er

Empty taco shells=ears

Legs are important. Do not skip this step.

Milk maker

Draw an eggplant.

Mooooooooo!

Add a face. A cute face. Cows are cute.

Ding!

Duck

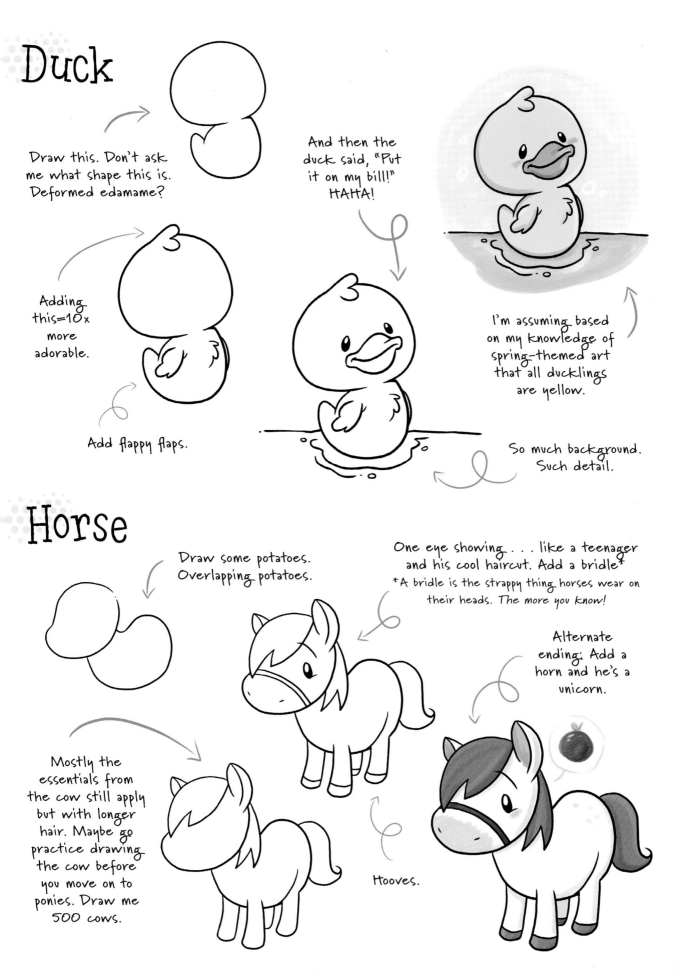

Draw this. Don't ask me what shape this is. Deformed edamame?

And then the duck said, "Put it on my bill!" HAHA!

Adding this=10x more adorable.

Add flappy flaps.

I'm assuming based on my knowledge of spring-themed art that all ducklings are yellow.

So much background. Such detail.

Horse

Draw some potatoes. Overlapping potatoes.

One eye showing . . . like a teenager and his cool haircut. Add a bridle*

*A bridle is the strappy thing horses wear on their heads. The more you know!

Alternate ending: Add a horn and he's a unicorn.

Mostly the essentials from the cow still apply but with longer hair. Maybe go practice drawing the cow before you move on to ponies. Draw me 500 cows.

Hooves.

Llama

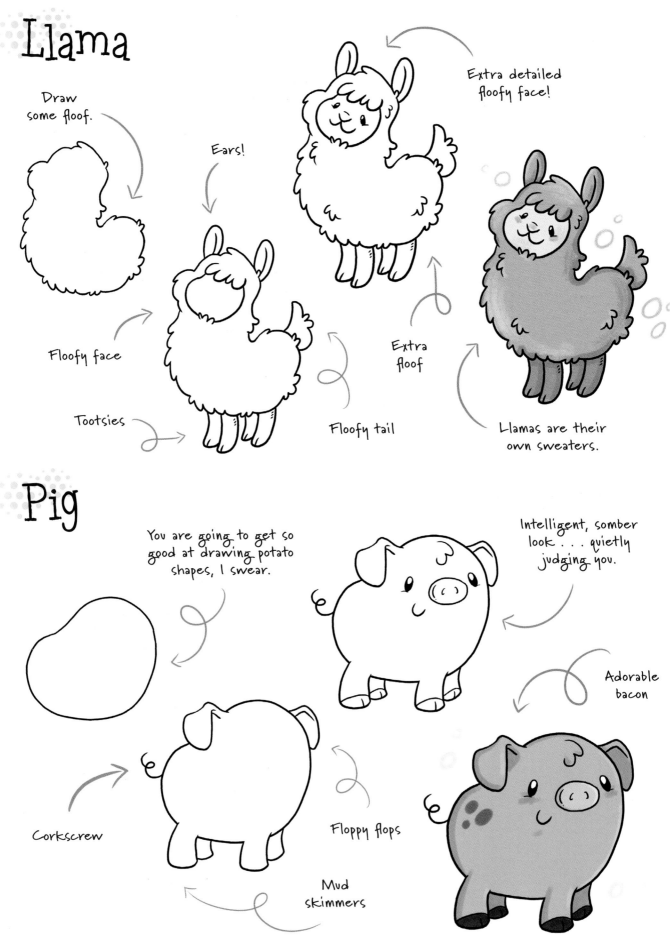

Draw some floof.

Ears!

Extra detailed floofy face!

Floofy face

Tootsies

Extra floof

Floofy tail

Llamas are their own sweaters.

Pig

You are going to get so good at drawing potato shapes, I swear.

Intelligent, somber look . . . quietly judging you.

Adorable bacon

Corkscrew

Floppy flops

Mud skimmers

Sheep

Draw a cotton ball.

Fwuffy, wuffy widdle baby

Ears!

FLUFFY TAIL!

4 legs. 4 is the optimal number . . . 5 is too many legs.

Add adorable!

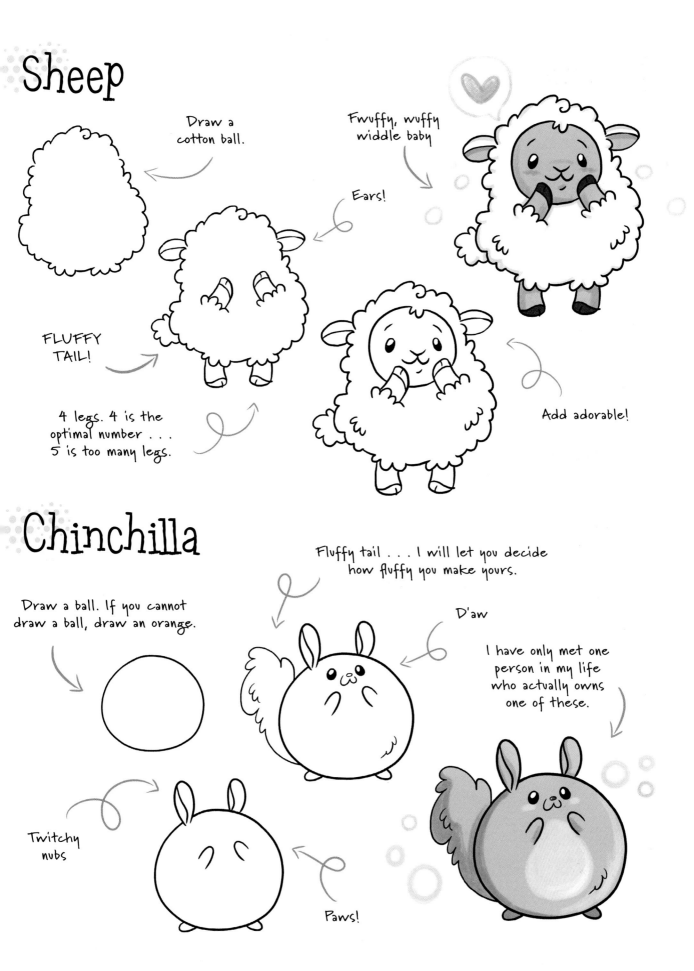

Chinchilla

Draw a ball. If you cannot draw a ball, draw an orange.

Fluffy tail . . . I will let you decide how fluffy you make yours.

D'aw

I have only met one person in my life who actually owns one of these.

Twitchy nubs

Paws!

Mixed Breed Dog

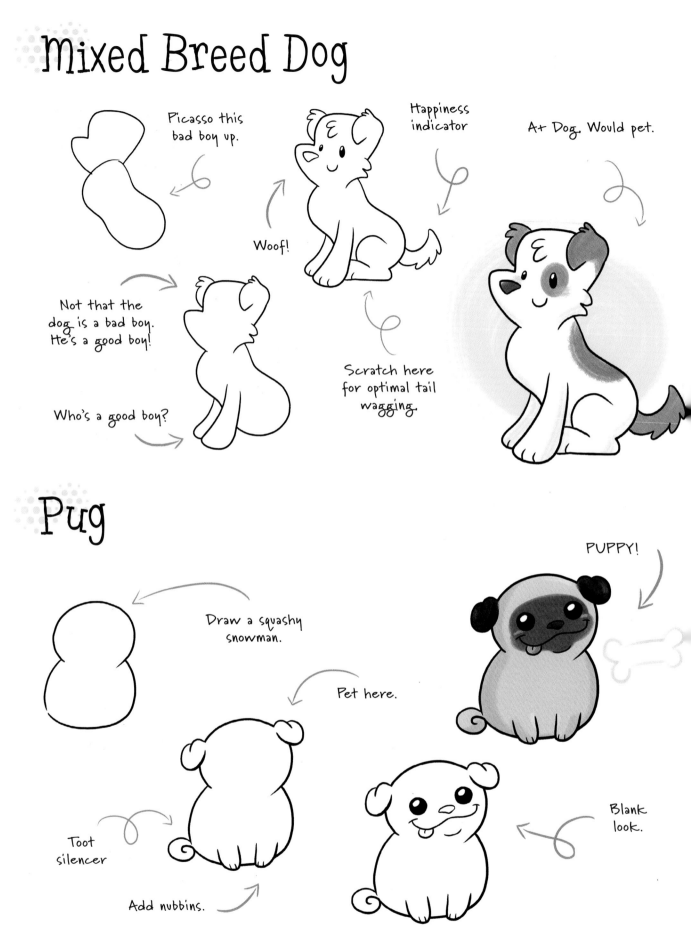

Picasso this bad boy up.

Happiness indicator

A+ Dog. Would pet.

Woof!

Not that the dog is a bad boy. He's a good boy!

Who's a good boy?

Scratch here for optimal tail wagging.

Pug

Draw a squashy snowman.

PUPPY!

Pet here.

Toot silencer

Add nubbins.

Blank look.

Poodle

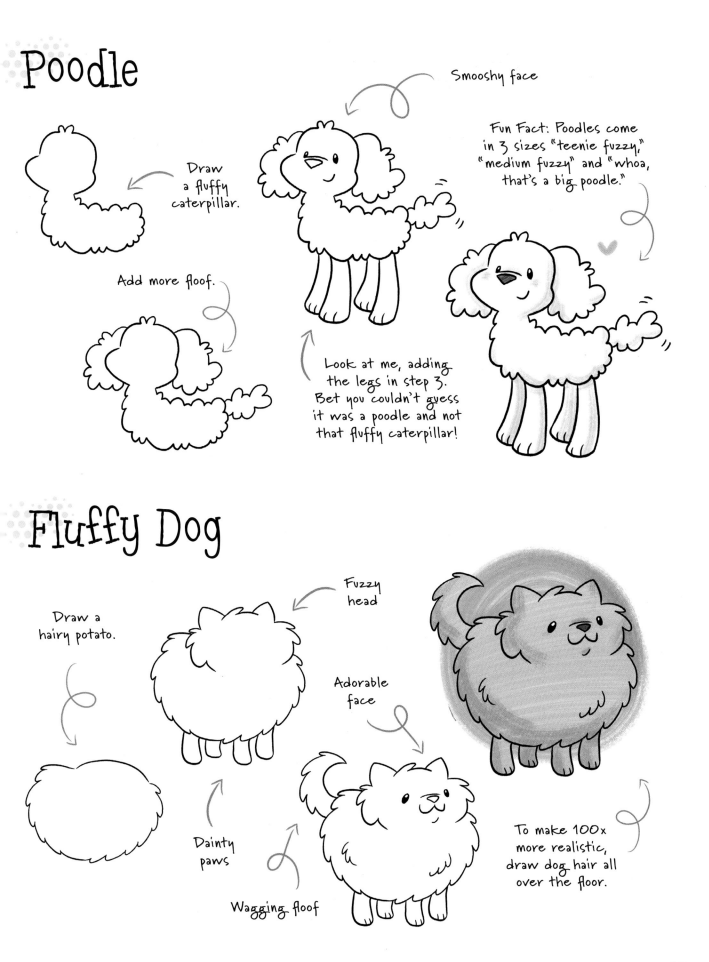

Draw a fluffy caterpillar.

Add more floof.

Smooshy face

Fun Fact: Poodles come in 3 sizes "teenie fuzzy," "medium fuzzy" and "whoa, that's a big poodle."

Look at me, adding the legs in step 3. Bet you couldn't guess it was a poodle and not that fluffy caterpillar!

Fluffy Dog

Draw a hairy potato.

Fuzzy head

Adorable face

Dainty paws

Wagging floof

To make 100x more realistic, draw dog hair all over the floor.

Goldfish

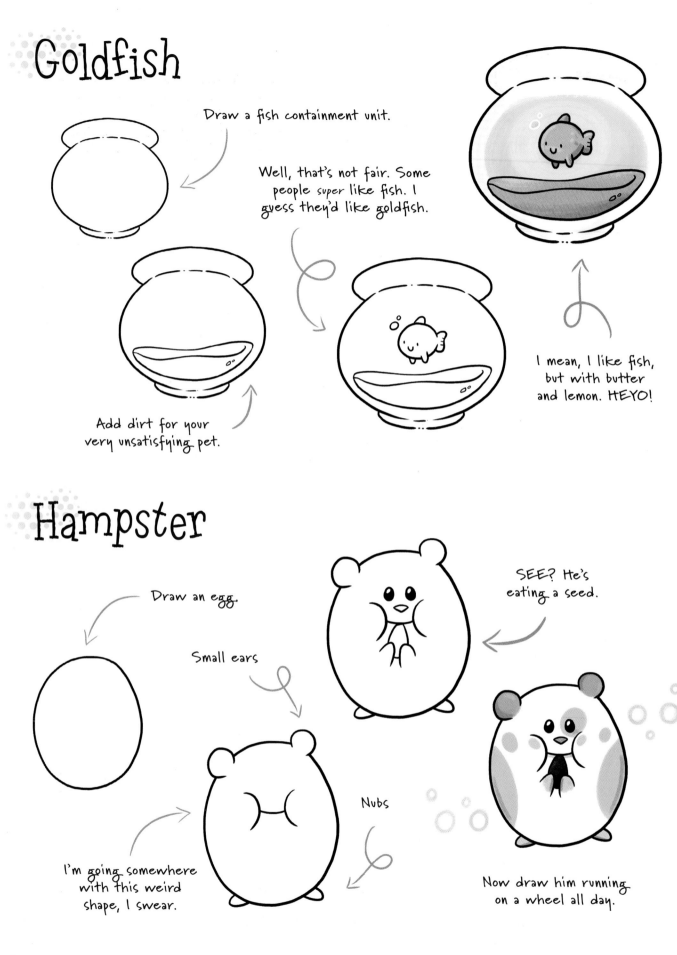

Draw a fish containment unit.

Well, that's not fair. Some people *super* like fish. I guess they'd like goldfish.

Add dirt for your very unsatisfying pet.

I mean, I like fish, but with butter and lemon. HEYO!

Hampster

Draw an egg.

Small ears

I'm going somewhere with this weird shape, I swear.

Nubs

SEE? He's eating a seed.

Now draw him running on a wheel all day.

Hedgehog

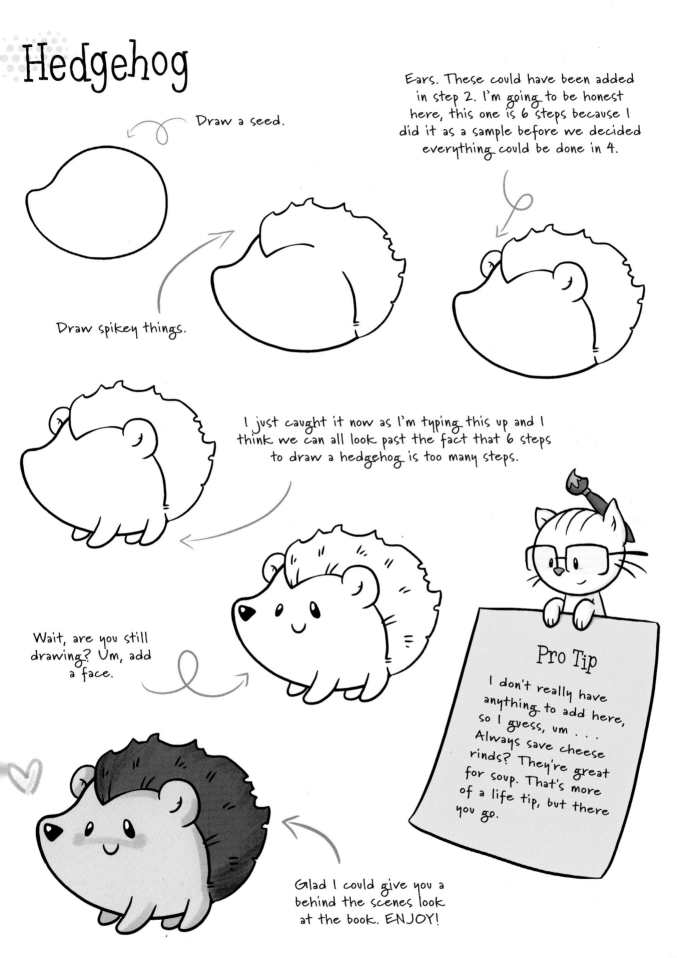

Draw a seed.

Ears. These could have been added in step 2. I'm going to be honest here, this one is 6 steps because I did it as a sample before we decided everything could be done in 4.

Draw spikey things.

I just caught it now as I'm typing this up and I think we can all look past the fact that 6 steps to draw a hedgehog is too many steps.

Wait, are you still drawing? Um, add a face.

Pro Tip

I don't really have anything to add here, so I guess, um . . . Always save cheese rinds? They're great for soup. That's more of a life tip, but there you go.

Glad I could give you a behind the scenes look at the book. ENJOY!

Cat

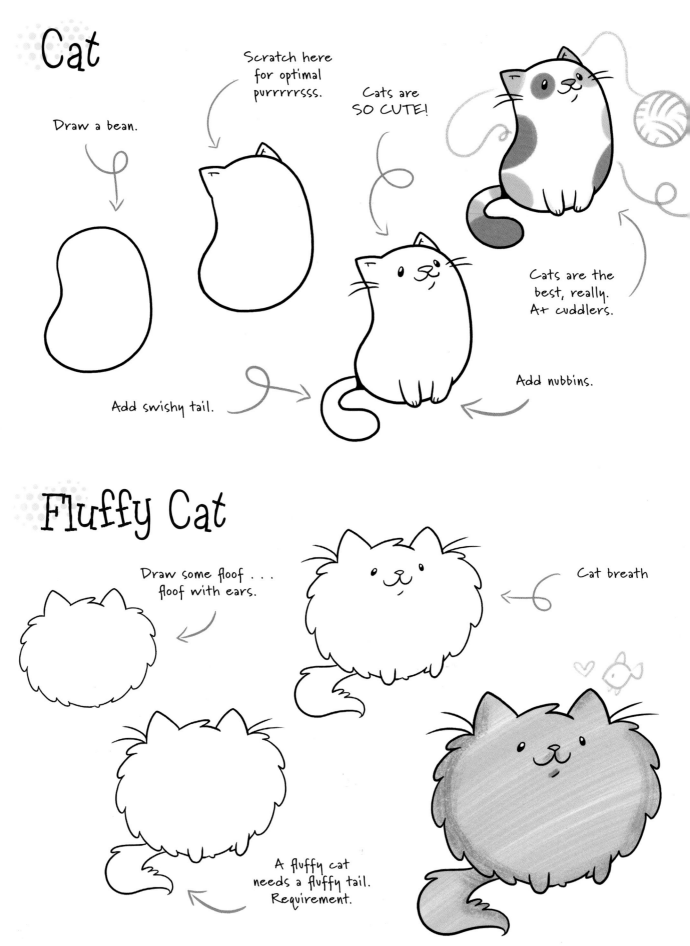

Draw a bean.

Scratch here for optimal purrrrrsss.

Cats are SO CUTE!

Cats are the best, really. A+ cuddlers.

Add swishy tail.

Add nubbins.

Fluffy Cat

Draw some floof . . . floof with ears.

Cat breath

A fluffy cat needs a fluffy tail. Requirement.

16

Cat in a Box

I'm going to guess you're getting pretty great at drawing cats by now, so I'm going to jump right into "draw this cat-like shape."

Now add a box.

Heads and tails.

TA DA!

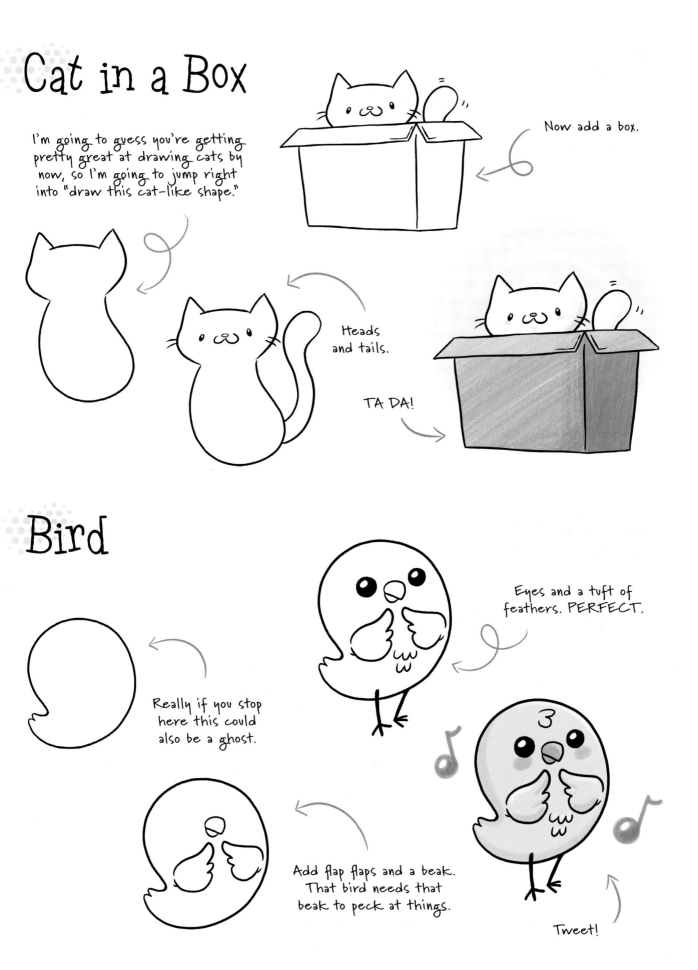

Bird

Really if you stop here this could also be a ghost.

Add flap flaps and a beak. That bird needs that beak to peck at things.

Eyes and a tuft of feathers. PERFECT.

Tweet!

Jellyfish

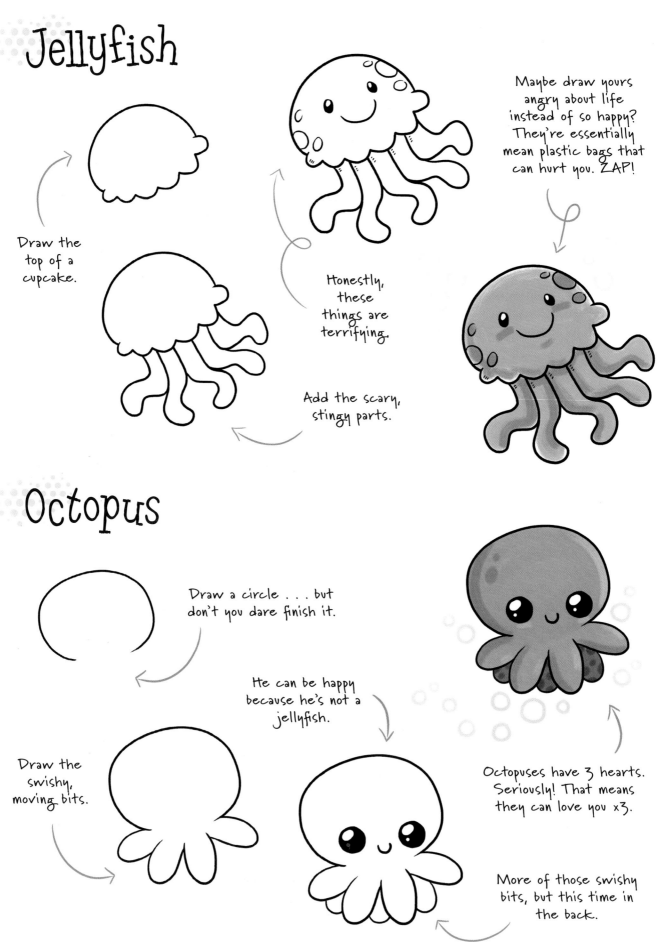

Draw the top of a cupcake.

Honestly, these things are terrifying.

Add the scary, stingy parts.

Maybe draw yours angry about life instead of so happy? They're essentially mean plastic bags that can hurt you. ZAP!

Octopus

Draw a circle . . . but don't you dare finish it.

He can be happy because he's not a jellyfish.

Draw the swishy, moving bits.

Octopuses have 3 hearts. Seriously! That means they can love you x3.

More of those swishy bits, but this time in the back.

Turtle

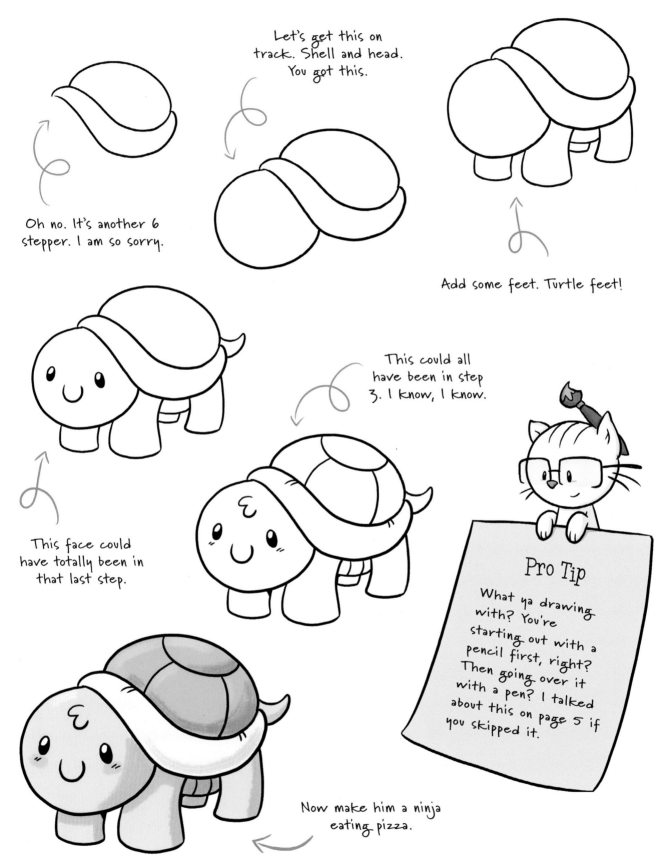

Oh no. It's another 6 stepper. I am so sorry.

Let's get this on track. Shell and head. You got this.

Add some feet. Turtle feet!

This face could have totally been in that last step.

This could all have been in step 3. I know, I know.

Pro Tip

What ya drawing with? You're starting out with a pencil first, right? Then going over it with a pen? I talked about this on page 5 if you skipped it.

Now make him a ninja eating pizza.

Whale

Draw a fish.

Keep on drawing that fish.

And whales aren't fish. They're mammals.

Surprise! It's not a fish, it's a whale!

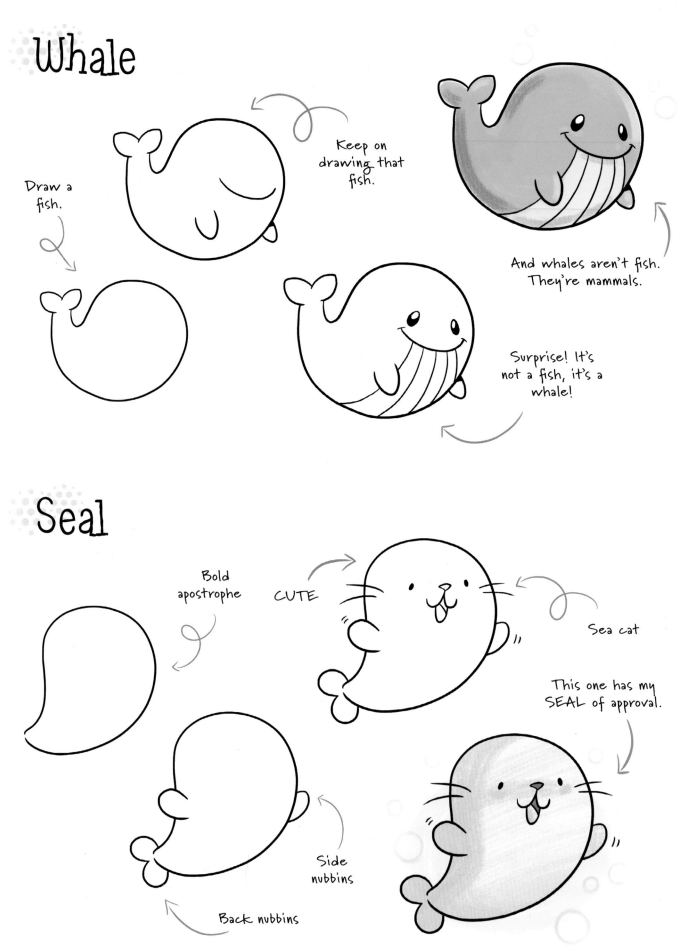

Seal

Bold apostrophe

CUTE

Sea cat

This one has my SEAL of approval.

Side nubbins

Back nubbins

Otter

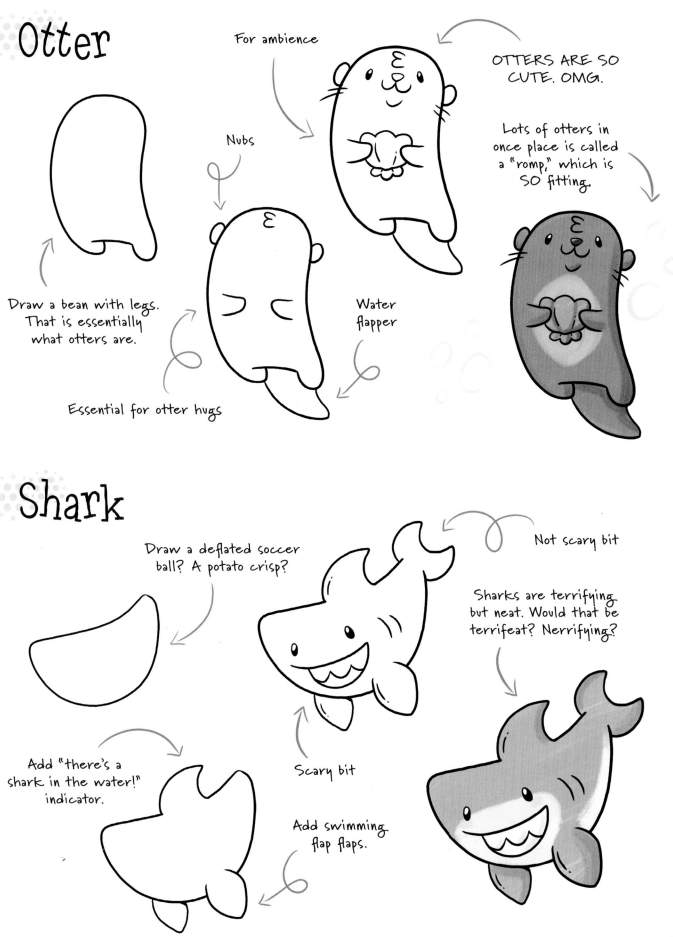

For ambience

OTTERS ARE SO CUTE. OMG.

Nubs

Lots of otters in once place is called a "romp," which is SO fitting.

Draw a bean with legs. That is essentially what otters are.

Water flapper

Essential for otter hugs

Shark

Draw a deflated soccer ball? A potato crisp?

Not scary bit

Sharks are terrifying but neat. Would that be terrifeat? Nerrifying?

Add "there's a shark in the water!" indicator.

Scary bit

Add swimming flap flaps.

Alligator

We're just going to dive right in and draw the head. Lots of bubbly shapes.

To be fair, this isn't super complicated. This could also be a crocodile.

Hands and feet!

Add this slug-like shape?

Really, I can never remember the difference between an alligator and a crocodile. One has a pointy snout? They're both toothy nightmares. Whatever.

Crab

I can't imagine looking at a crab and thinking, "I should eat that." I mean, come on. Ew.

Add the grabby bits.

Draw a rock. Not a big rock, a pleasantly small rock.

Legs! Face! CUTE. Well, as cute as a crab is going to get.

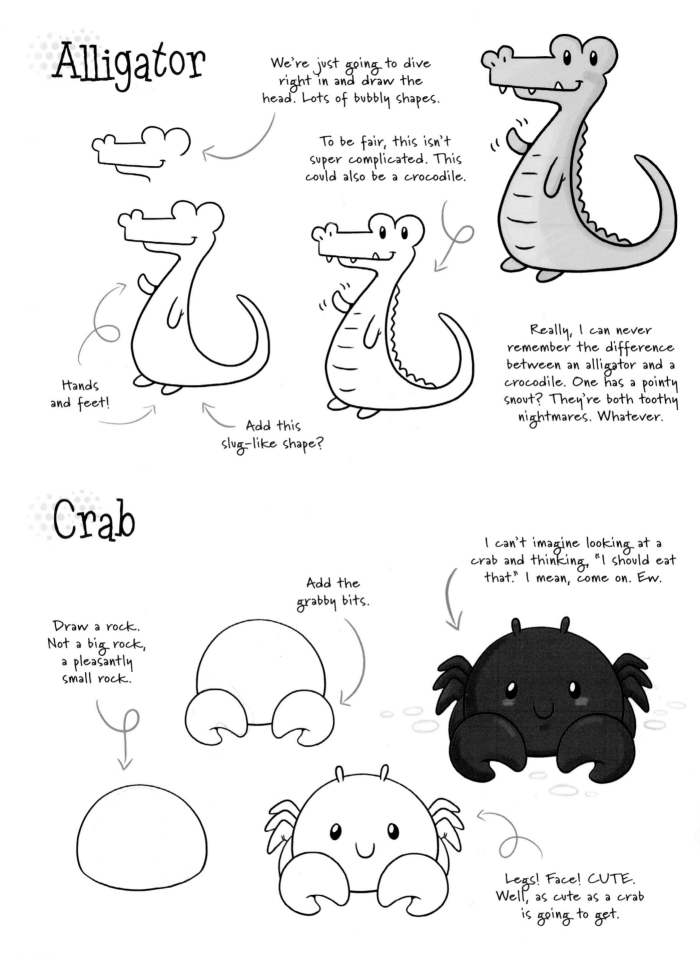

Frog

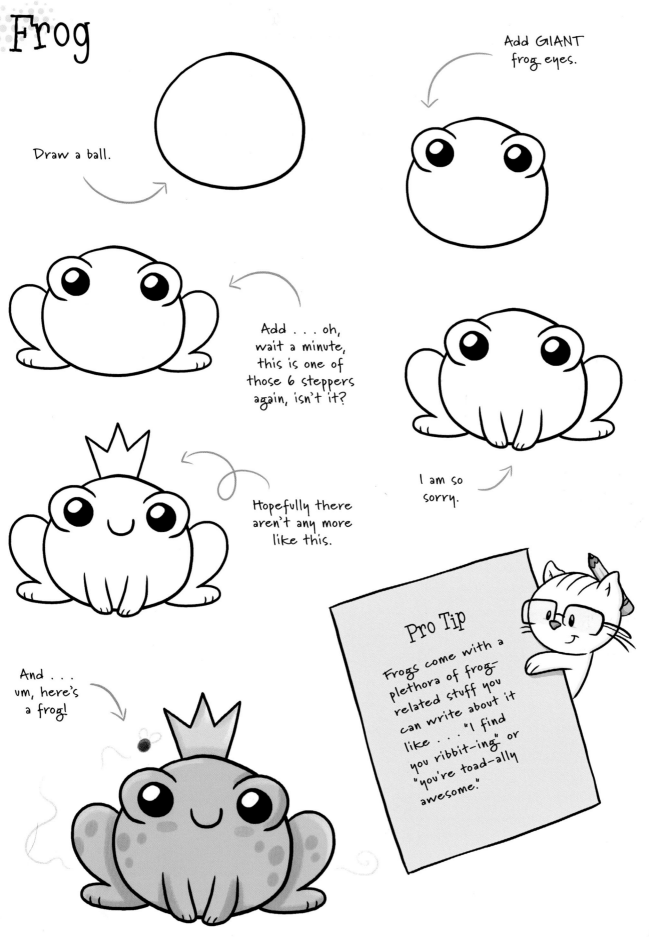

Draw a ball.

Add GIANT frog eyes.

Add . . . oh, wait a minute, this is one of those 6 steppers again, isn't it?

I am so sorry.

Hopefully there aren't any more like this.

And . . . um, here's a frog!

Pro Tip

Frogs come with a plethora of frog-related stuff you can write about it like . . . "I find you ribbit-ing" or "you're toad-ally awesome."

Walrus

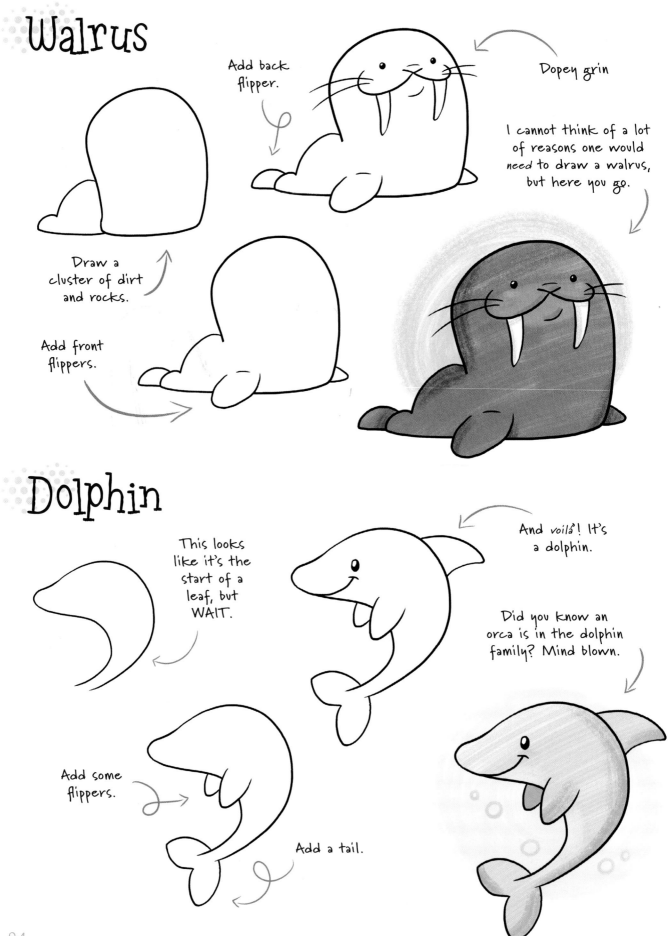

Add back flipper.

Dopey grin

I cannot think of a lot of reasons one would need to draw a walrus, but here you go.

Draw a cluster of dirt and rocks.

Add front flippers.

Dolphin

This looks like it's the start of a leaf, but WAIT.

And *voilà*! It's a dolphin.

Did you know an orca is in the dolphin family? Mind blown.

Add some flippers.

Add a tail.

Clam

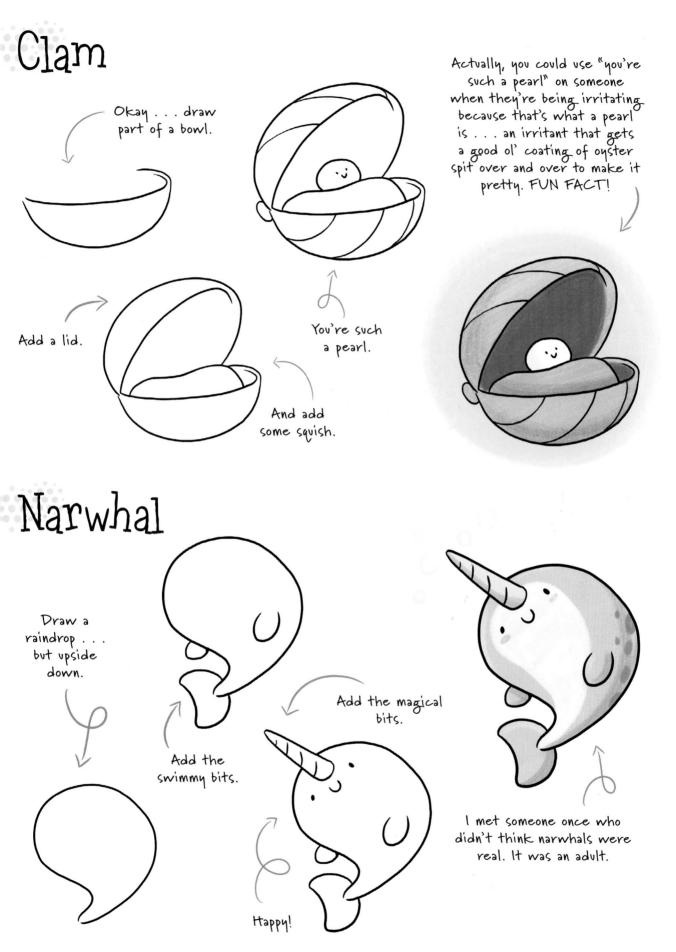

Okay . . . draw part of a bowl.

Add a lid.

And add some squish.

You're such a pearl.

Actually, you could use "you're such a pearl" on someone when they're being irritating because that's what a pearl is . . . an irritant that gets a good ol' coating of oyster spit over and over to make it pretty. FUN FACT!

Narwhal

Draw a raindrop . . . but upside down.

Add the swimmy bits.

Add the magical bits.

Happy!

I met someone once who didn't think narwhals were real. It was an adult.

Manta Ray

Kinda looks like a deformed pizza.

Manta rays have tails. Stingrays have stingy parts here.

Add these nubby bits.

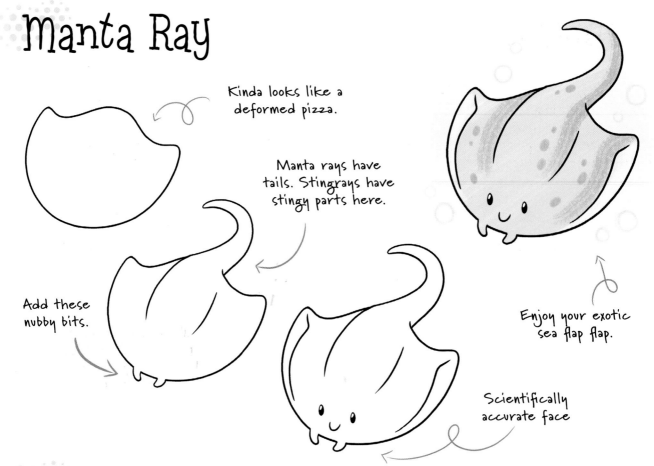

Enjoy your exotic sea flap flap.

Scientifically accurate face

Seahorse

Maybe I have some deep-seeded belief that horses shouldn't be in the sea.

This is the head, I swear.

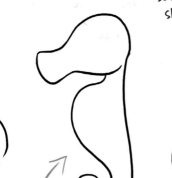

I am notoriously bad at drawing seahorses. It's like a mental block.

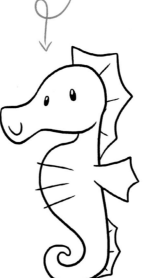

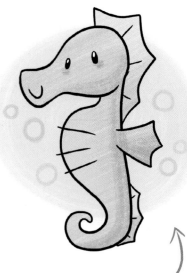

Well, that turned out better than expected. How does yours look?

Penguin

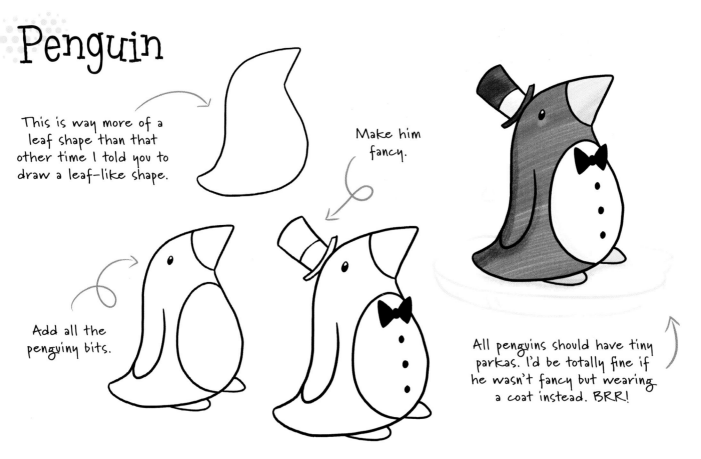

This is way more of a leaf shape than that other time I told you to draw a leaf-like shape.

Make him fancy.

Add all the penguiny bits.

All penguins should have tiny parkas. I'd be totally fine if he wasn't fancy but wearing a coat instead. BRR!

~~Snake~~ Danger Noodle

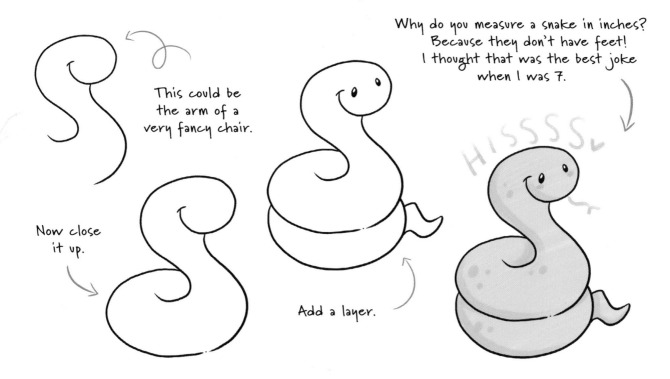

This could be the arm of a very fancy chair.

Now close it up.

Add a layer.

Why do you measure a snake in inches? Because they don't have feet! I thought that was the best joke when I was 7.

HISSSS

Fox

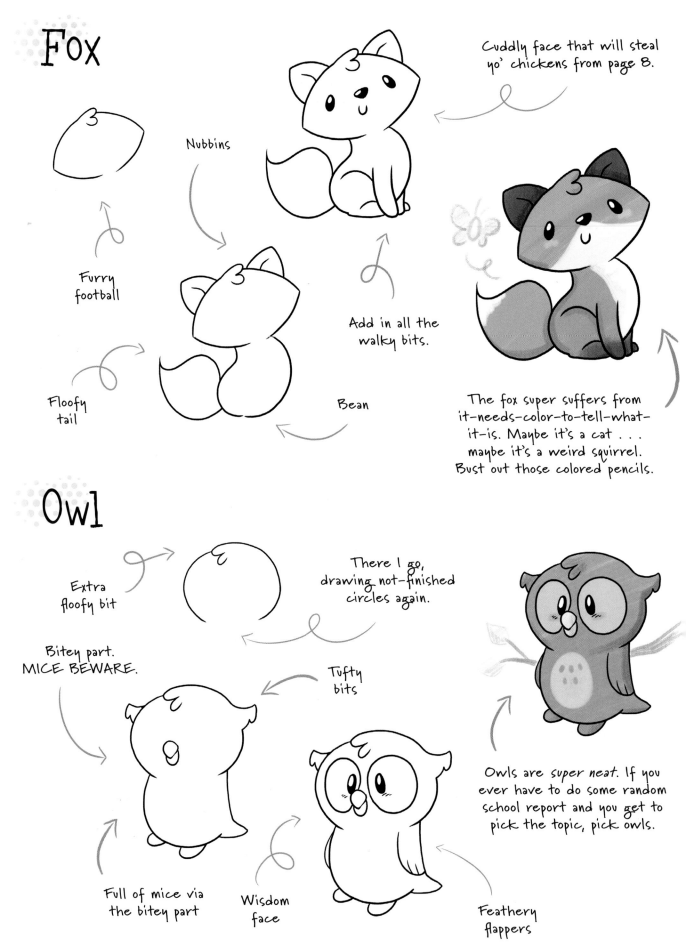

Cuddly face that will steal yo' chickens from page 8.

Nubbins

Furry football

Floofy tail

Add in all the walky bits.

Bean

The fox super suffers from it-needs-color-to-tell-what-it-is. Maybe it's a cat . . . maybe it's a weird squirrel. Bust out those colored pencils.

Owl

Extra floofy bit

There I go, drawing not-finished circles again.

Bitey part. MICE BEWARE.

Tufty bits

Full of mice via the bitey part

Wisdom face

Feathery flappers

Owls are super neat. If you ever have to do some random school report and you get to pick the topic, pick owls.

Bear

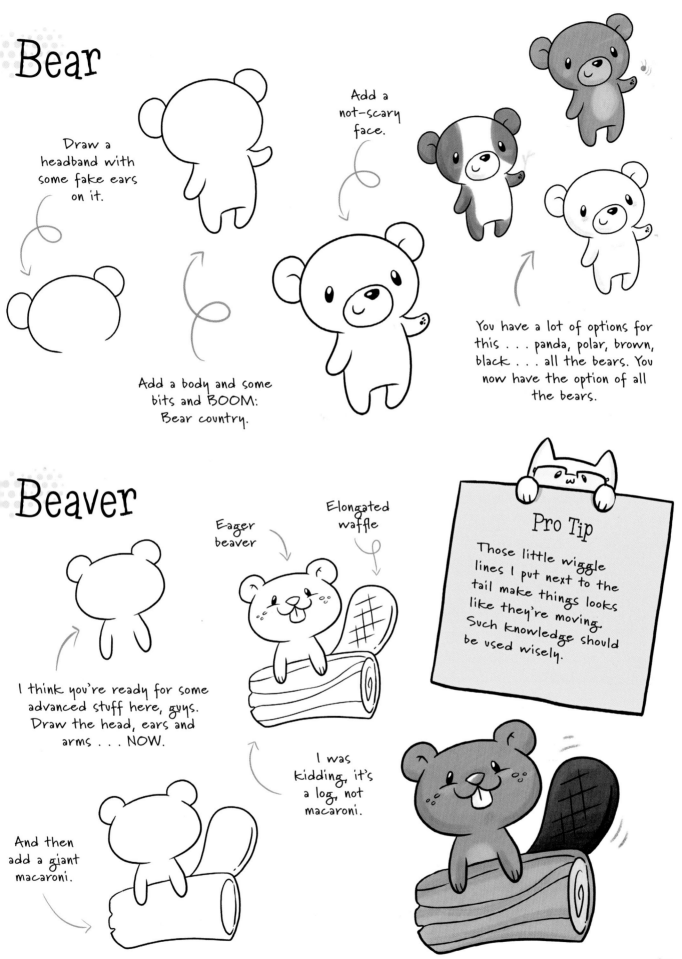

Draw a headband with some fake ears on it.

Add a body and some bits and BOOM: Bear country.

Add a not-scary face.

You have a lot of options for this . . . panda, polar, brown, black . . . all the bears. You now have the option of all the bears.

Beaver

I think you're ready for some advanced stuff here, guys. Draw the head, ears and arms . . . NOW.

And then add a giant macaroni.

I was kidding, it's a log, not macaroni.

Eager beaver

Elongated waffle

Pro Tip

Those little wiggle lines I put next to the tail make things looks like they're moving. Such knowledge should be used wisely.

29

Moose

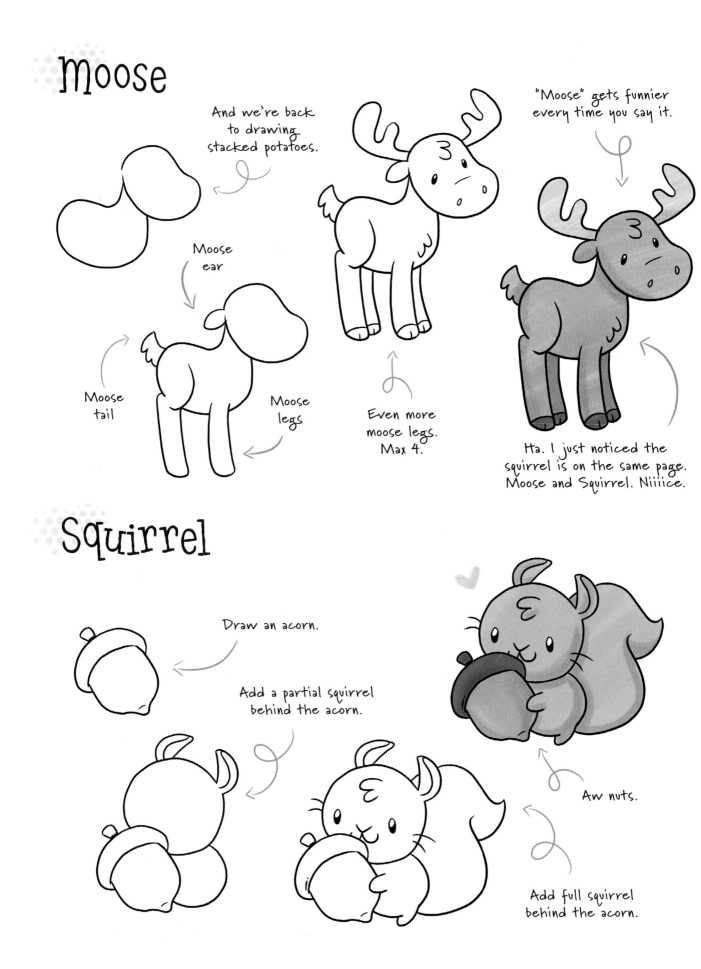

And we're back to drawing stacked potatoes.

Moose ear

Moose tail

Moose legs

Even more moose legs. Max 4.

"Moose" gets funnier every time you say it.

Ha. I just noticed the squirrel is on the same page. Moose and Squirrel. Niiiice.

Squirrel

Draw an acorn.

Add a partial squirrel behind the acorn.

Add full squirrel behind the acorn.

Aw nuts.

Bunny

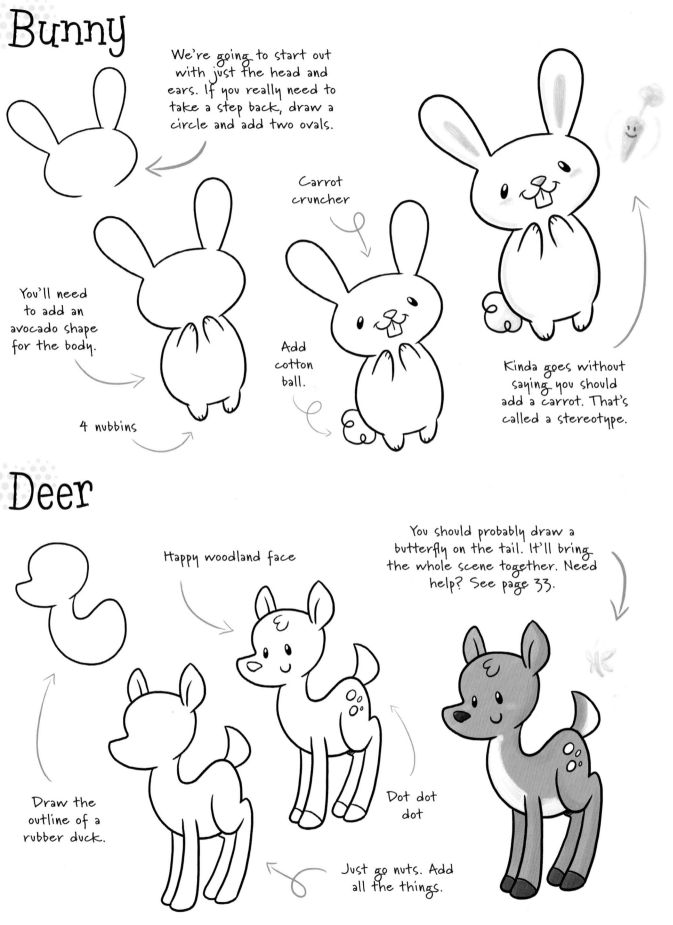

We're going to start out with just the head and ears. If you really need to take a step back, draw a circle and add two ovals.

You'll need to add an avocado shape for the body.

4 nubbins

Carrot cruncher

Add cotton ball.

Kinda goes without saying you should add a carrot. That's called a stereotype.

Deer

Happy woodland face

You should probably draw a butterfly on the tail. It'll bring the whole scene together. Need help? See page 33.

Draw the outline of a rubber duck.

Dot dot dot

Just go nuts. Add all the things.

Snail

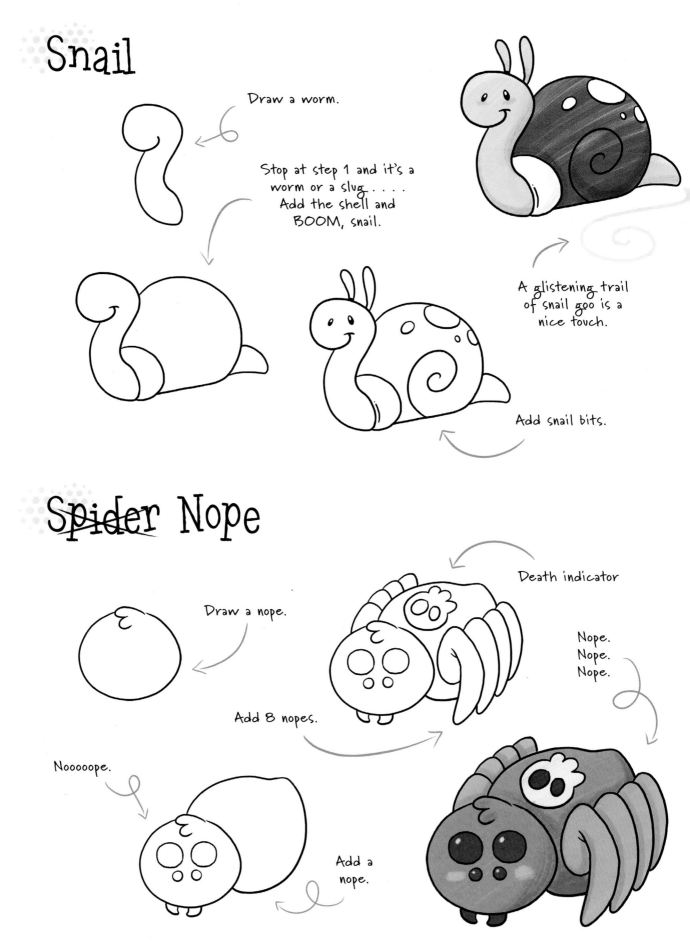

Draw a worm.

Stop at step 1 and it's a worm or a slug Add the shell and BOOM, snail.

A glistening trail of snail goo is a nice touch.

Add snail bits.

Spider Nope

Draw a nope.

Add 8 nopes.

Noooooope.

Add a nope.

Death indicator

Nope.
Nope.
Nope.

Bee

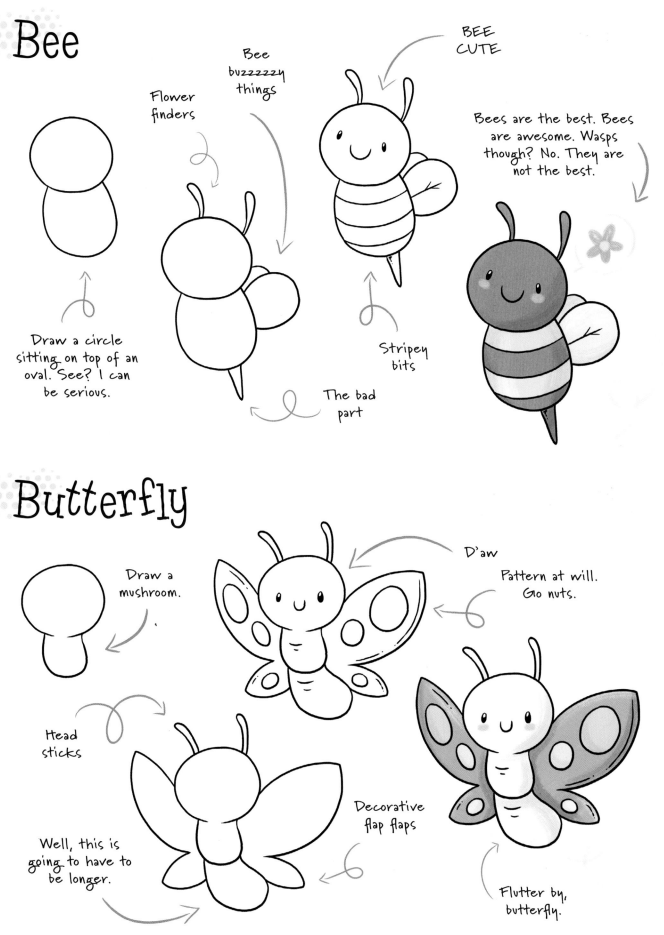

Flower finders

Bee buzzzzzy things

BEE CUTE

Bees are the best. Bees are awesome. Wasps though? No. They are not the best.

Draw a circle sitting on top of an oval. See? I can be serious.

The bad part

Stripey bits

Butterfly

Draw a mushroom.

D'aw

Pattern at will. Go nuts.

Head sticks

Decorative flap flaps

Well, this is going to have to be longer.

Flutter by, butterfly.

Firefly

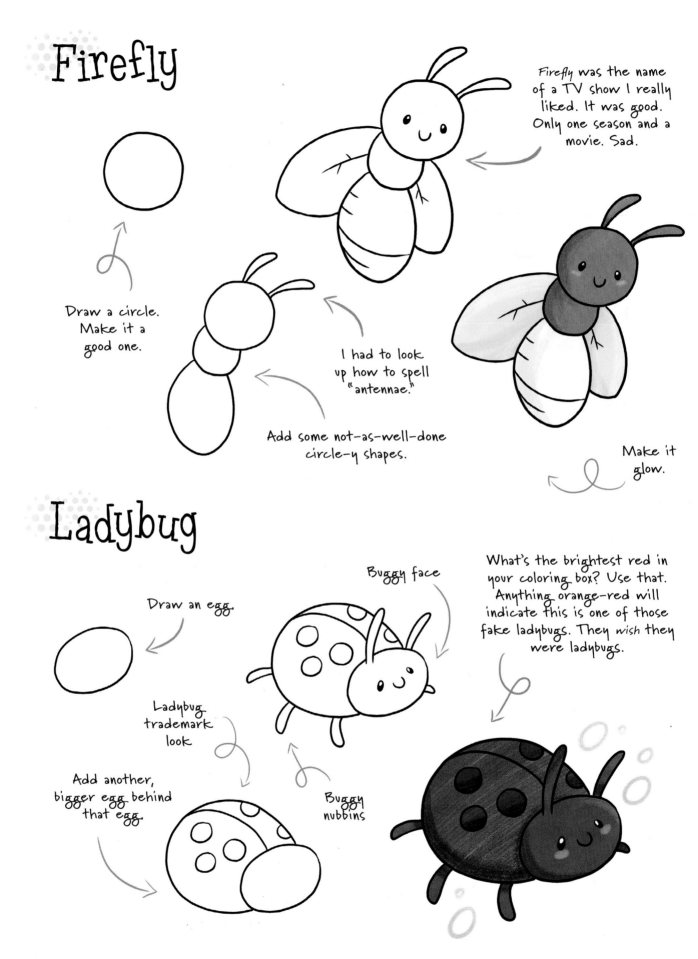

Draw a circle. Make it a good one.

Add some not-as-well-done circle-y shapes.

I had to look up how to spell "antennae."

Firefly was the name of a TV show I really liked. It was good. Only one season and a movie. Sad.

Make it glow.

Ladybug

Draw an egg

Add another, bigger egg behind that egg.

Ladybug trademark look

Buggy face

Buggy nubbins

What's the brightest red in your coloring box? Use that. Anything orange-red will indicate this is one of those fake ladybugs. They *wish* they were ladybugs.

Lion

Draw a terrible bowling pin.

Add a mane if your lion is a boy. Skip this if it's a lady.

ROAR!

Safari stompers

For listening for zebras

Do not pull.

Tiger

Draw an even worse bowling pin.

Without these, you have a panther. RAR!

Stripey tail

Add tree.

Do not scratch. Not a normal kitty.

Add leisurely pose.

Orange and black are a classic pairing.

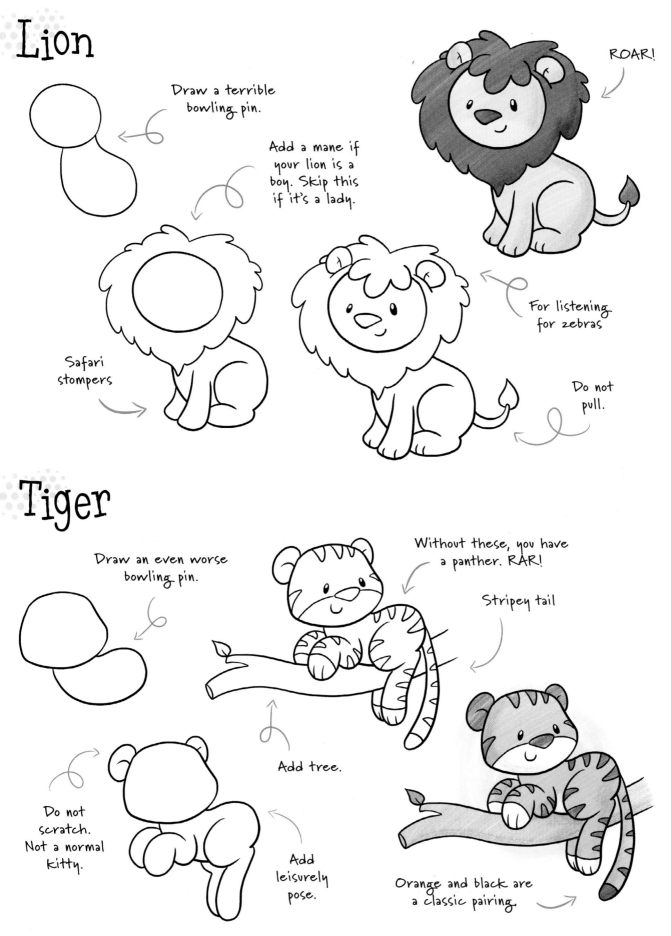

Red Panda

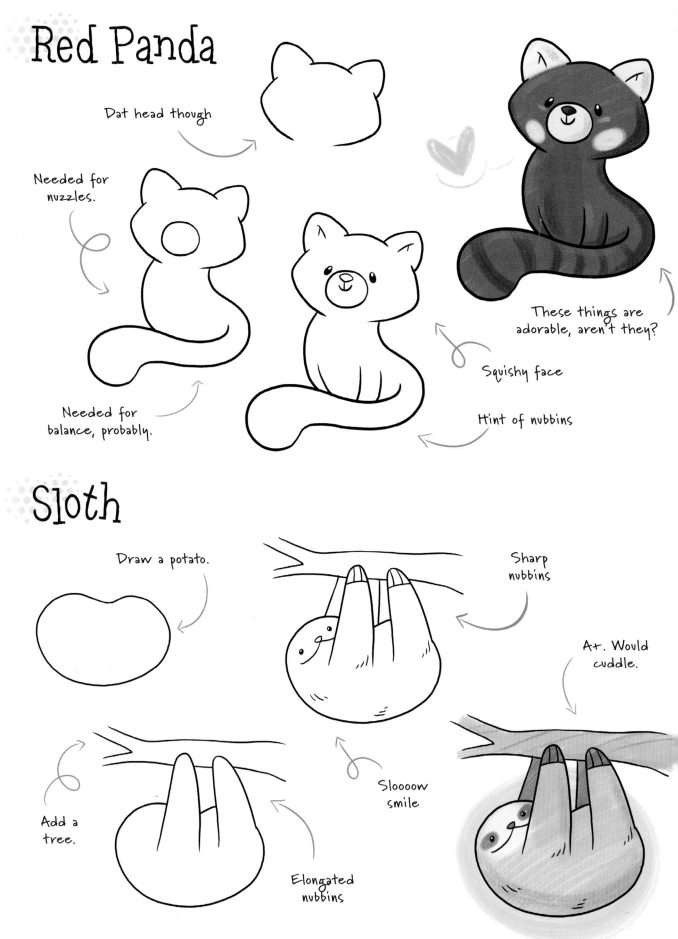

Dat head though

Needed for nuzzles.

Needed for balance, probably.

These things are adorable, aren't they?

Squishy face

Hint of nubbins

Sloth

Draw a potato.

Sharp nubbins

A+. Would cuddle.

Add a tree.

Slooooow smile

Elongated nubbins

Hippo

Draw an egg.

Add a head. Ears, too. Chop chop.

Did you know hippos are terrifying? Seriously.

Add friend.

Add 4 buckets . . . or feet. Same dif.

Swisher

Add hippo characteristics.

Elephant

Draw a tombstone

Tiny in comparison

Not flap flaps

Add peanut.

Add a trunk

Toenails, I guess?

Stompy nubbins

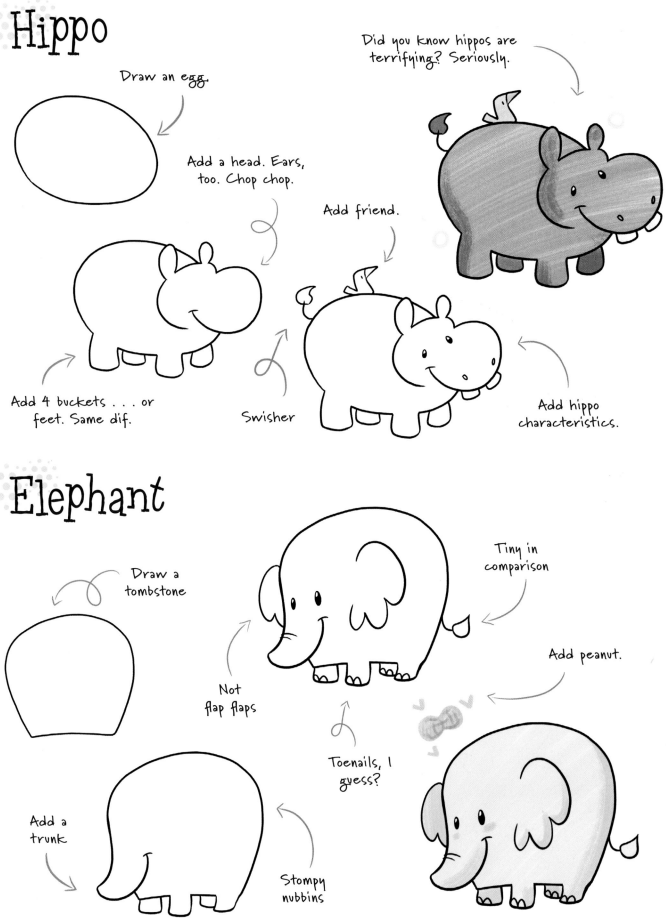

Giraffe

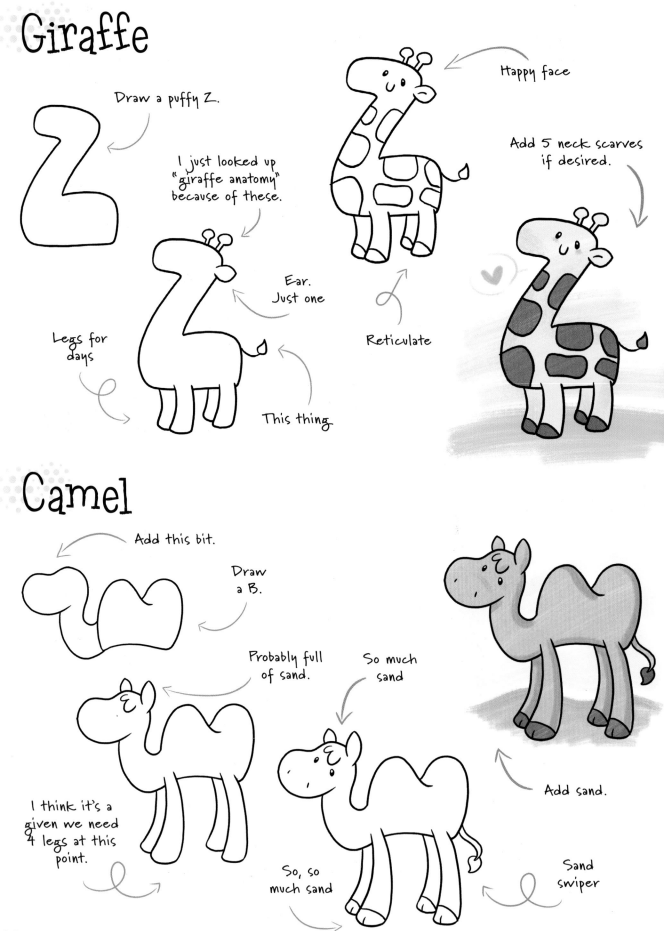

Draw a puffy Z.

I just looked up "giraffe anatomy" because of these.

Happy face

Add 5 neck scarves if desired.

Ear. Just one

Legs for days

This thing

Reticulate

Camel

Add this bit.

Draw a B.

Probably full of sand.

So much sand

I think it's a given we need 4 legs at this point.

So, so much sand

Add sand.

Sand swiper

Platypus

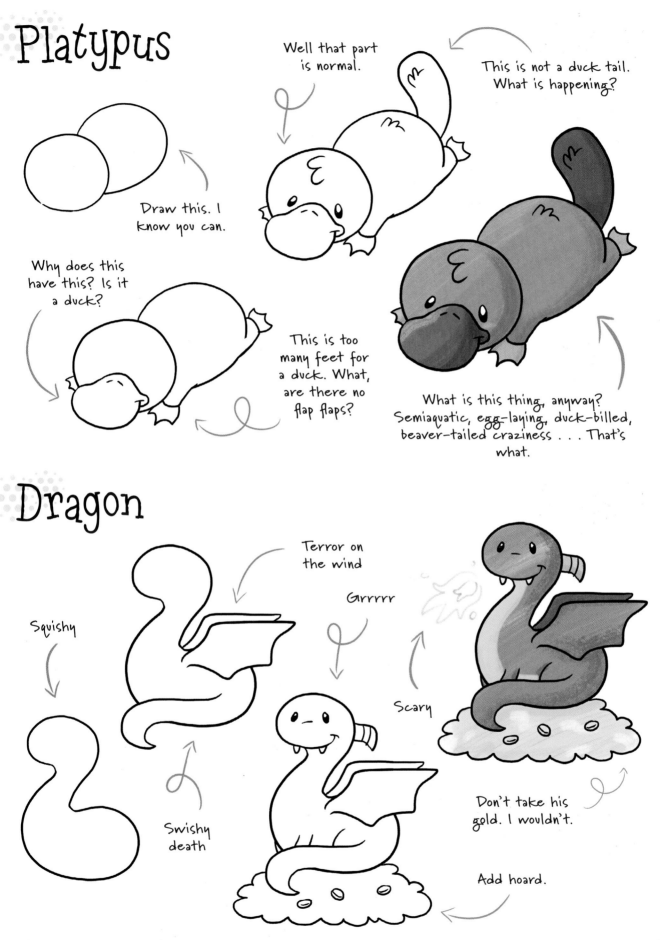

Draw this. I know you can.

Well that part is normal.

This is not a duck tail. What is happening?

Why does this have this? Is it a duck?

This is too many feet for a duck. What, are there no flap flaps?

What is this thing, anyway? Semiaquatic, egg-laying, duck-billed, beaver-tailed craziness . . . That's what.

Dragon

Squishy

Swishy death

Terror on the wind

Grrrrr

Scary

Don't take his gold. I wouldn't.

Add hoard.

Food Stuff

I think this is the longest bit in the book. You know why? Because food is great. Sandwiches in particular. But who doesn't love food? Crazy people, that's who. And who doesn't love adorable food? Even crazier people. Now grab your pencils and a brownie and dive in.

Cake

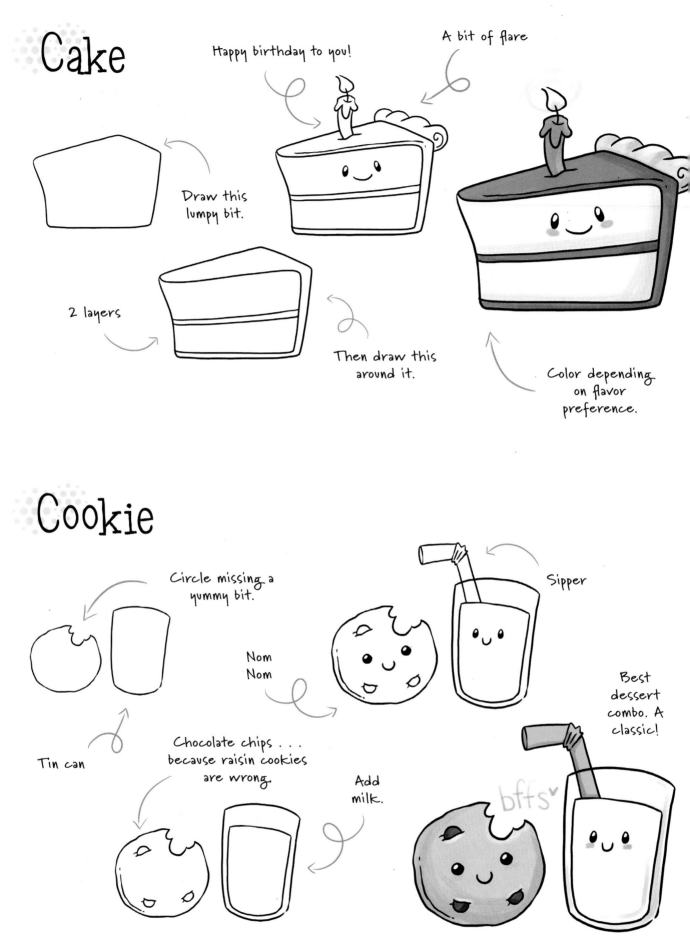

Happy birthday to you!

A bit of flare

Draw this lumpy bit.

2 layers

Then draw this around it.

Color depending on flavor preference.

Cookie

Circle missing a yummy bit.

Sipper

Nom Nom

Best dessert combo. A classic!

Tin can

Chocolate chips . . . because raisin cookies are wrong.

Add milk.

bfts♥

Cupcake

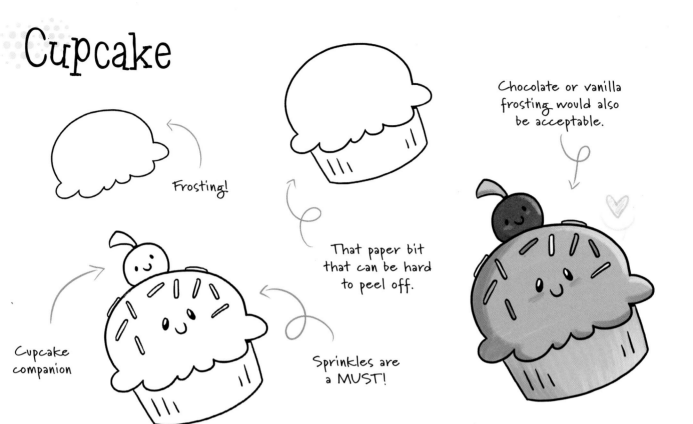

Frosting!

Chocolate or vanilla frosting would also be acceptable.

That paper bit that can be hard to peel off.

Cupcake companion

Sprinkles are a MUST!

Donut

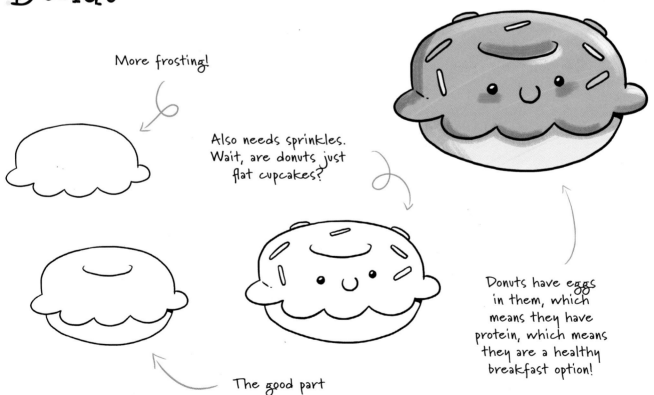

More frosting!

Also needs sprinkles. Wait, are donuts just flat cupcakes?

The good part

Donuts have eggs in them, which means they have protein, which means they are a healthy breakfast option!

Ice Cream

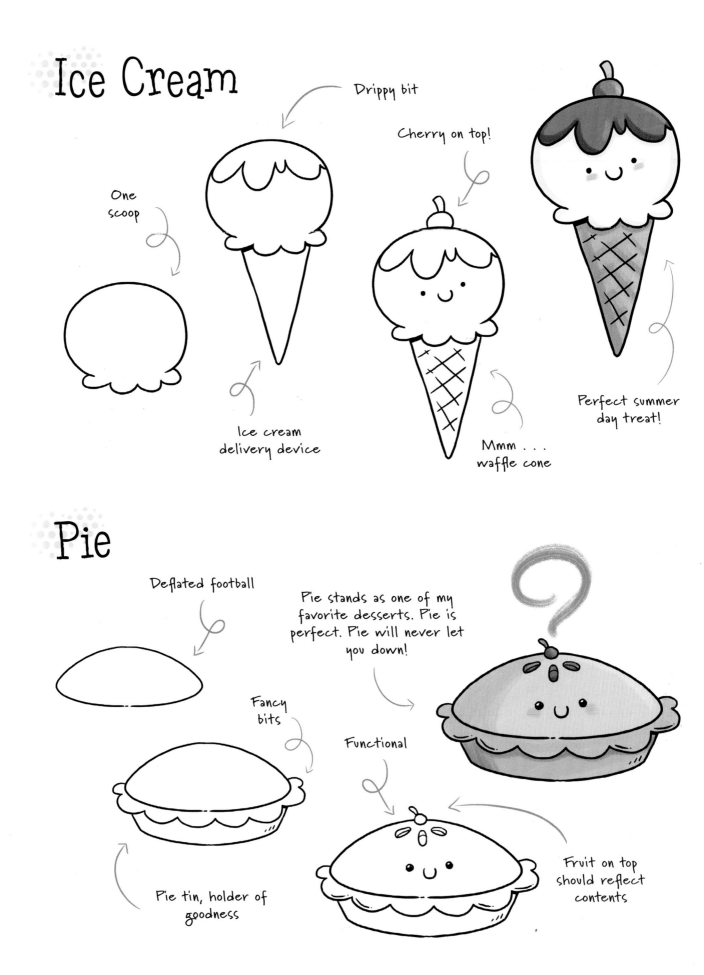

Drippy bit

Cherry on top!

One scoop

Ice cream delivery device

Mmm . . . waffle cone

Perfect summer day treat!

Pie

Deflated football

Pie stands as one of my favorite desserts. Pie is perfect. Pie will never let you down!

Fancy bits

Functional

Pie tin, holder of goodness

Fruit on top should reflect contents

Chocolates

Paper bit . . . just draw a crown.

Not a rock

Also not a rock

Choco nub

Decorative bit

Milk or dark?

Tea

Small bowl

Let steep

Addition of milk or honey optional

Holdy part

HOT

Leaves rings on coffee tables if not careful.

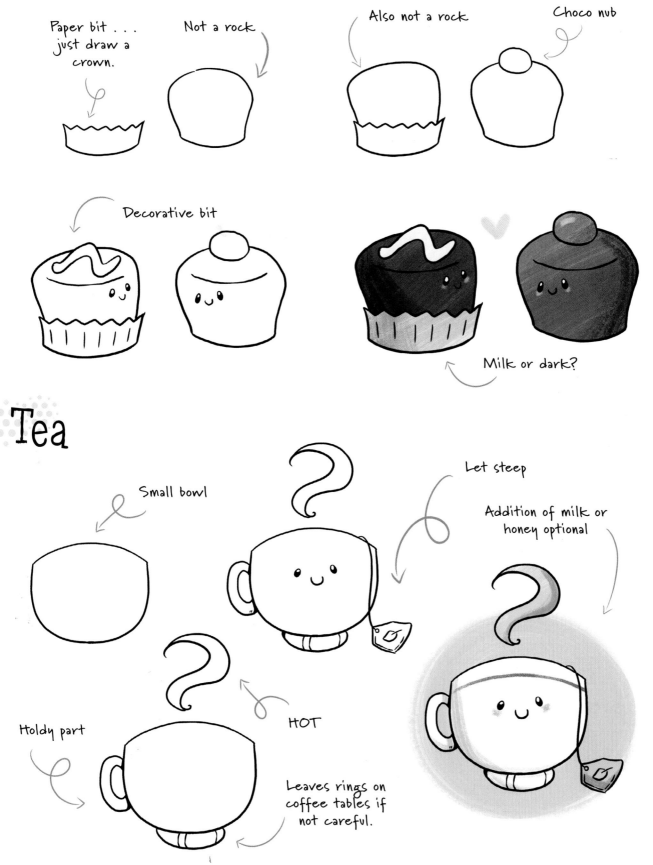

Milkshake

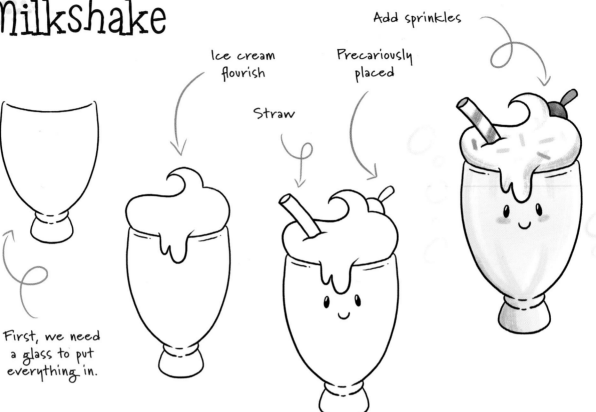

Ice cream flourish

Add sprinkles

Straw

Precariously placed

First, we need a glass to put everything in.

Tiki Drink

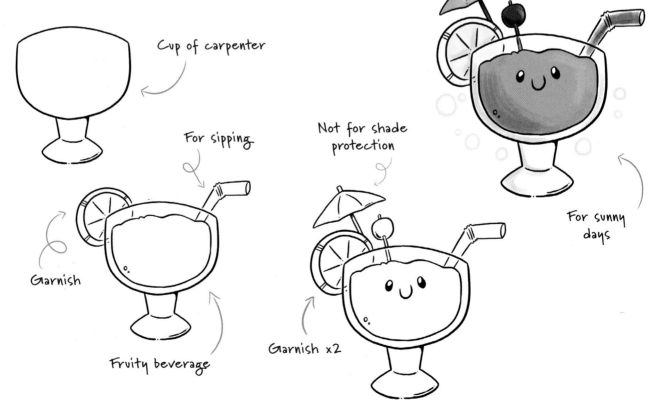

Cup of carpenter

For sipping

Not for shade protection

Garnish

Fruity beverage

Garnish x2

For sunny days

Teapot

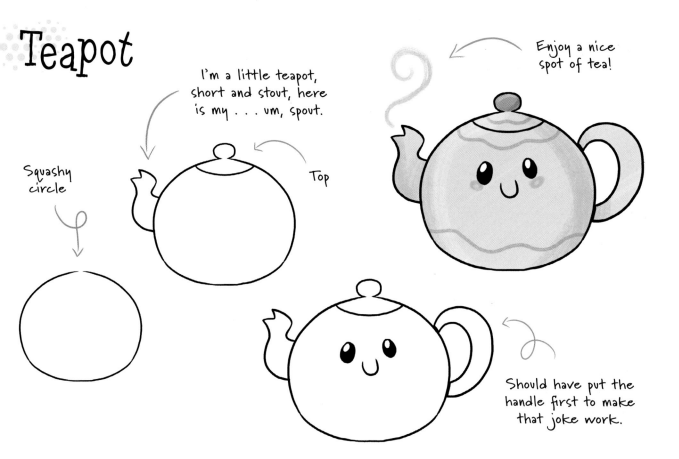

Squashy circle

I'm a little teapot, short and stout, here is my . . . um, spout.

Top

Enjoy a nice spot of tea!

Should have put the handle first to make that joke work.

Coffee to Go

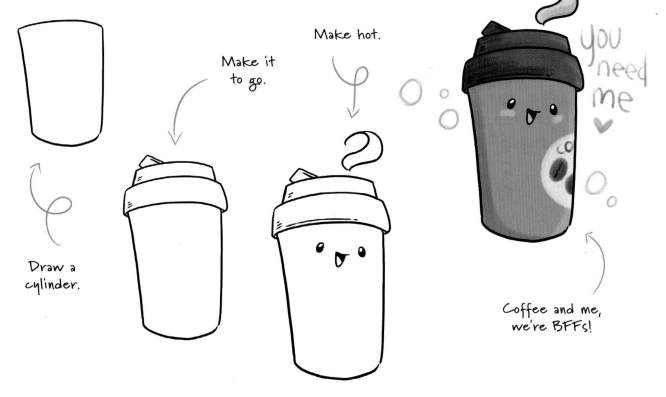

Draw a cylinder.

Make it to go.

Make hot.

you need me ♥

Coffee and me, we're BFFs!

Milk

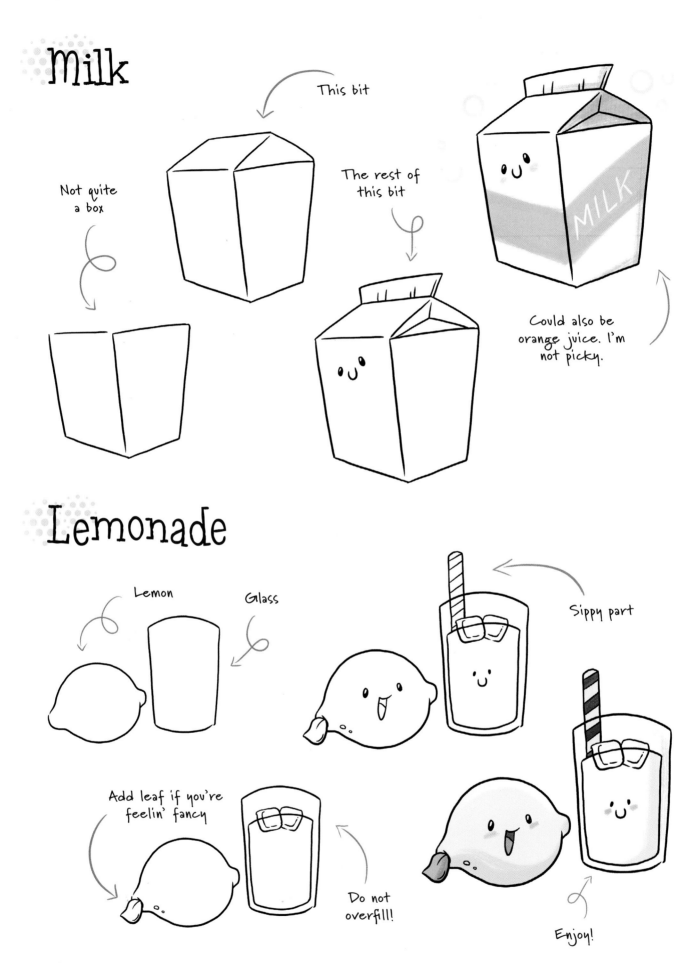

This bit

Not quite
a box

The rest of
this bit

MILK

Could also be
orange juice. I'm
not picky.

Lemonade

Lemon Glass

Sippy part

Add leaf if you're
feelin' fancy

Do not
overfill!

Enjoy!

Pineapple

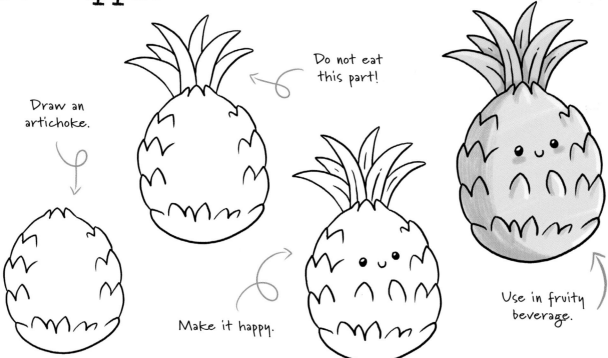

Draw an artichoke.

Do not eat this part!

Make it happy.

Use in fruity beverage.

Strawberry

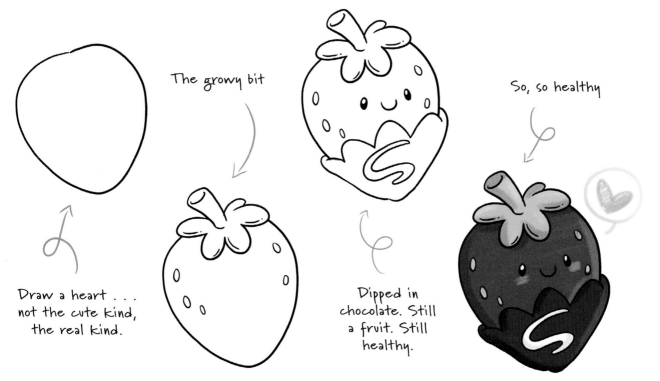

The growy bit

So, so healthy

Draw a heart . . . not the cute kind, the real kind.

Dipped in chocolate. Still a fruit. Still healthy.

Watermelon

Well this doesn't look like anything.

Well, it does if you do this.

Seeds!

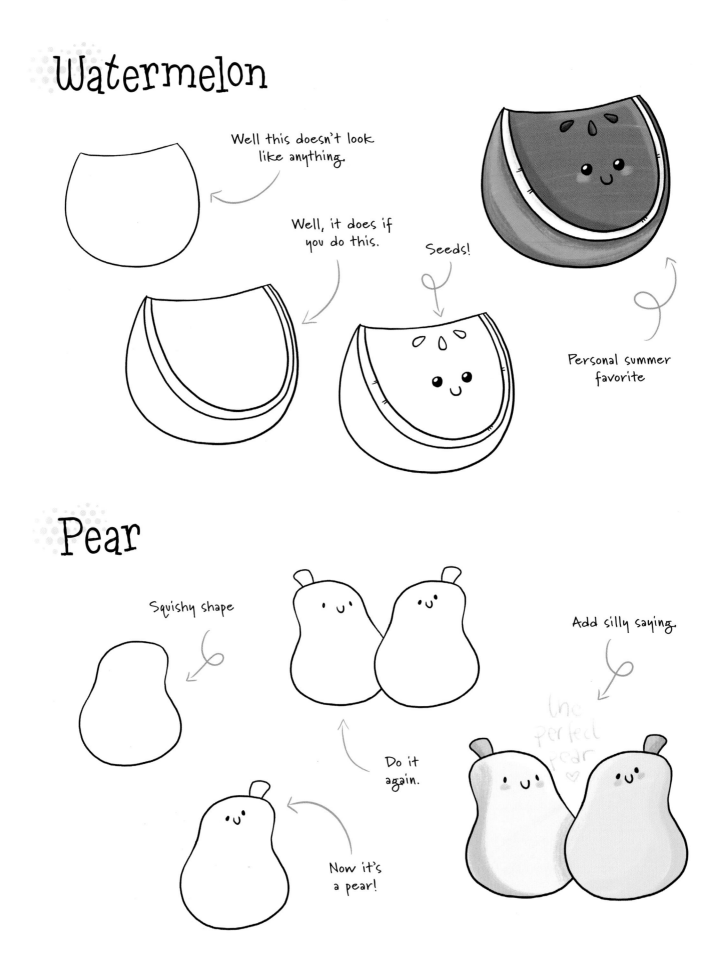

Personal summer favorite

Pear

Squishy shape

Do it again.

Now it's a pear!

Add silly saying.

the perfect pear ♡

Cherry

Circle!

Another circle!

Tie 'em together.

Just one more thing

You could draw just ONE cherry, but why not give him a friend?

Grapes

Draw a circle. A li'l one.

Then do it a bunch of times.

Ha! A BUNCH of times! Get it?

I didn't even plan that one, awesome!

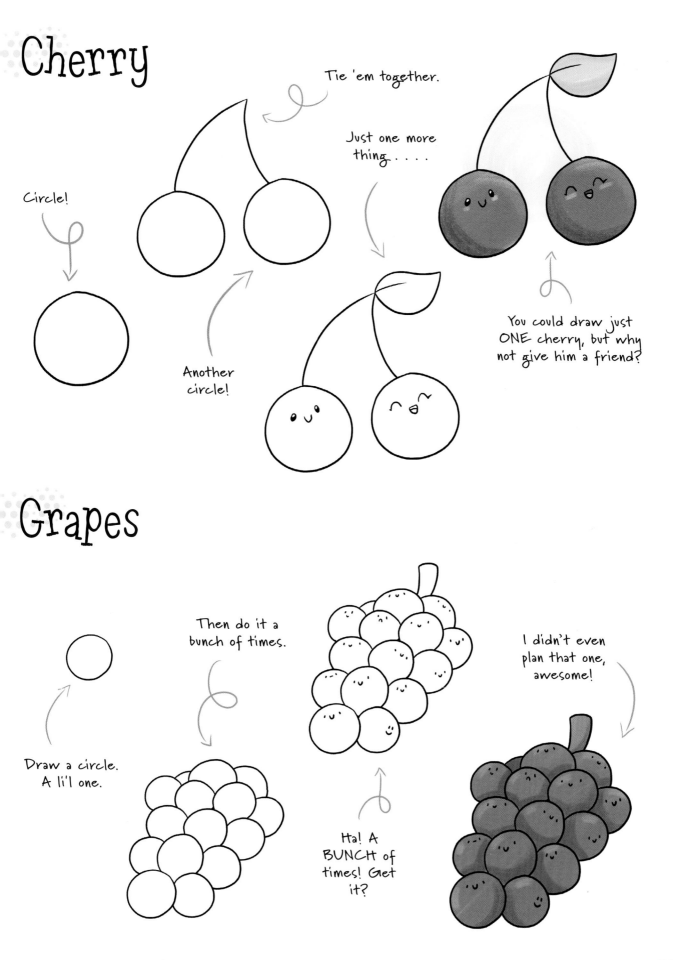

Apple

Another option: draw it with a bite out of it and a frowny face.

Extra apple-y shape

Adds character.

Or keep things happy, that's fine.

Avocado

I love avocados!

Like, really love them

All the guacamole

Charge me extra for guac, I don't care.

They look as happy as they make me!

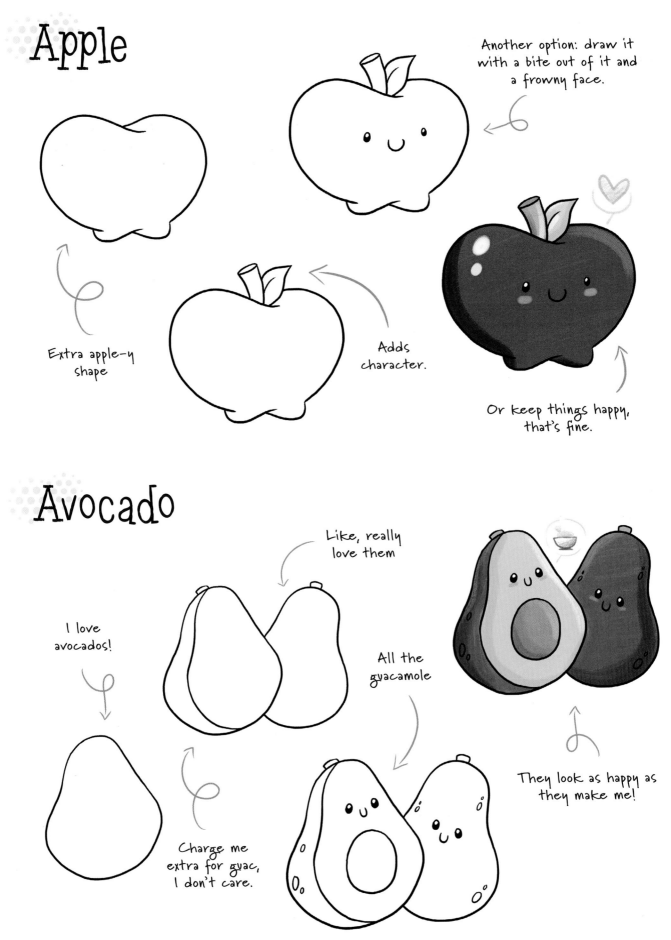

Mushroom

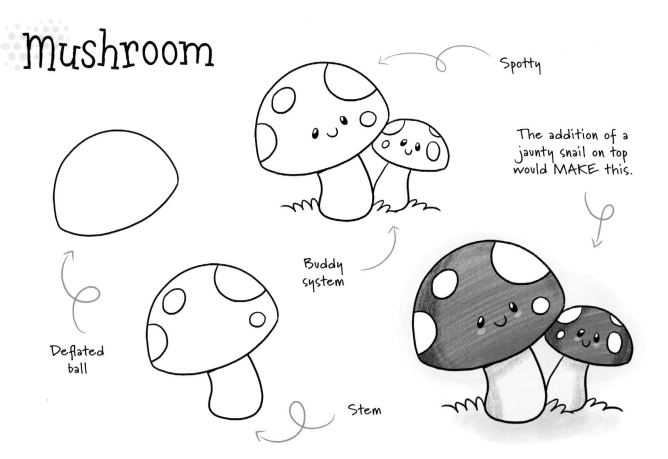

Spotty

The addition of a jaunty snail on top would MAKE this.

Buddy system

Deflated ball

Stem

Potato

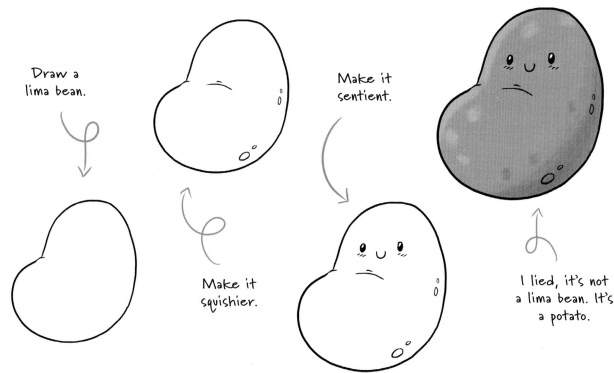

Draw a lima bean.

Make it sentient.

Make it squishier.

I lied, it's not a lima bean. It's a potato.

Bell Pepper

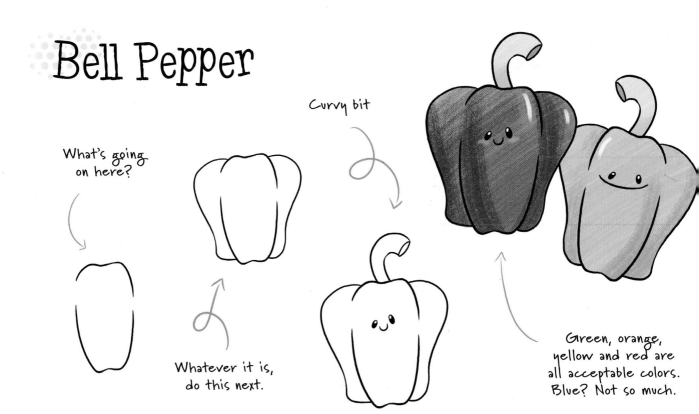

What's going on here?

Whatever it is, do this next.

Curvy bit

Green, orange, yellow and red are all acceptable colors. Blue? Not so much.

Jalepeño Pepper

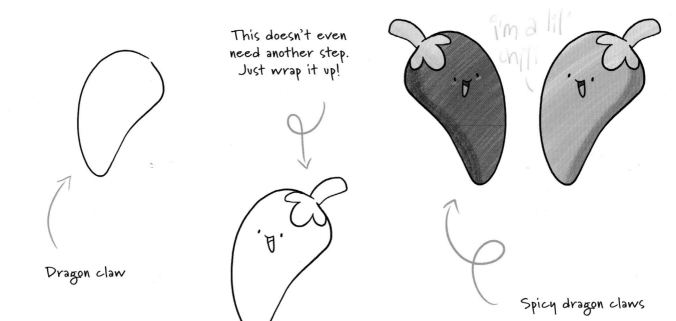

Dragon claw

This doesn't even need another step. Just wrap it up!

i'm a lil' chili

Spicy dragon claws

Bok Choy

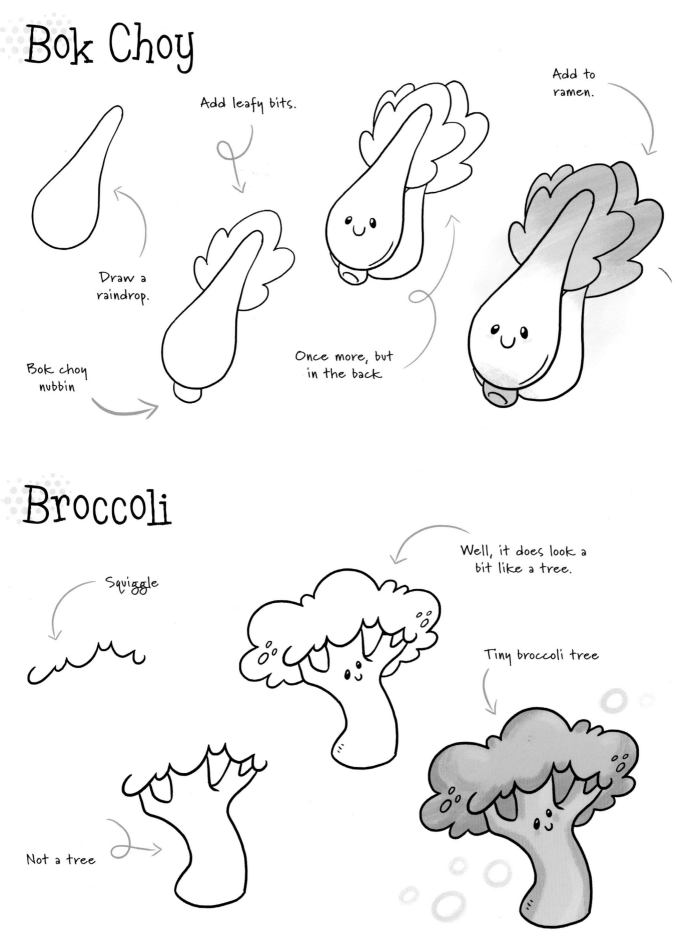

Add leafy bits.

Add to ramen.

Draw a raindrop.

Bok choy nubbin

Once more, but in the back

Broccoli

Squiggle

Well, it does look a bit like a tree.

Tiny broccoli tree

Not a tree

55

Soup

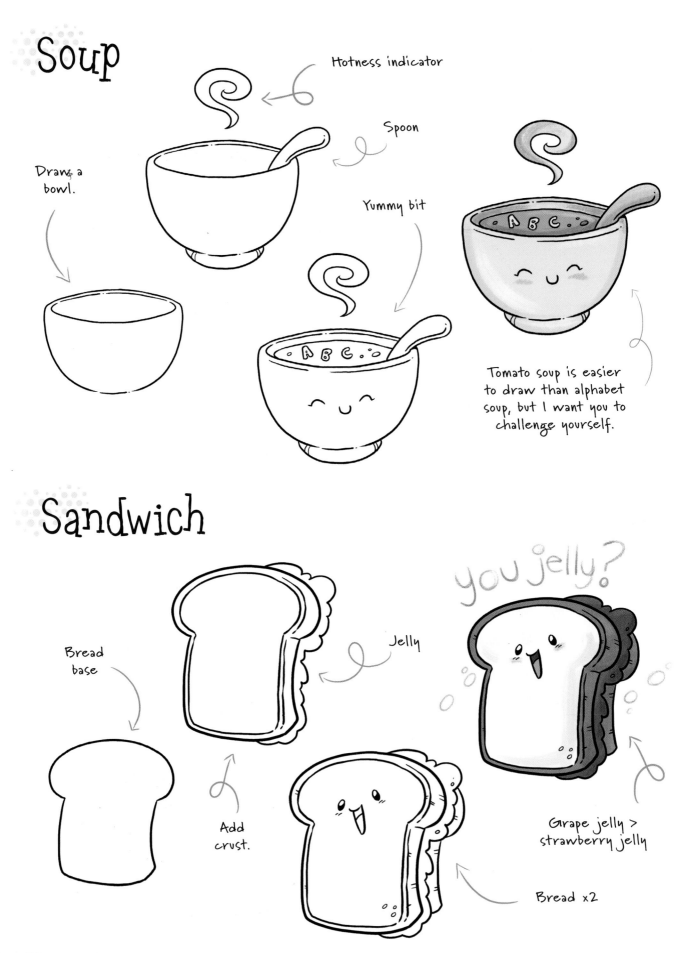

Hotness indicator

Spoon

Draw a bowl.

Yummy bit

Tomato soup is easier to draw than alphabet soup, but I want you to challenge yourself.

Sandwich

Bread base

Jelly

you jelly?

Add crust.

Grape jelly > strawberry jelly

Bread x2

Dumpling

Stick

Fancy bit

Another stick

Steamed or fried?

Not quite a football

Worried expression

Sushi

Not a goldfish

Can-like

Nom

Nom

HOT

Rice

Adorable eats

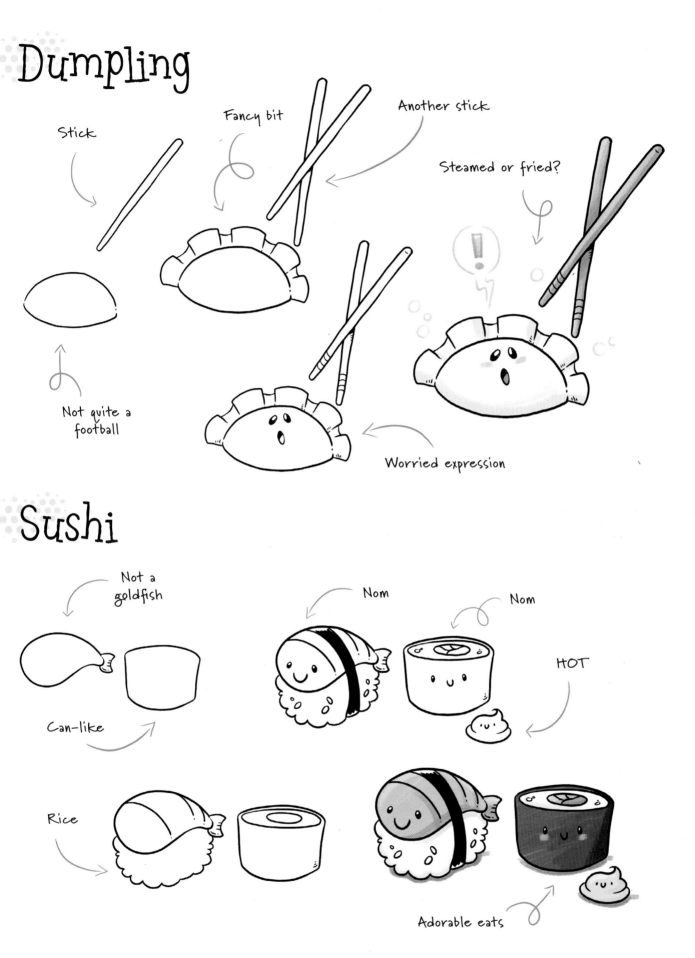

Fries

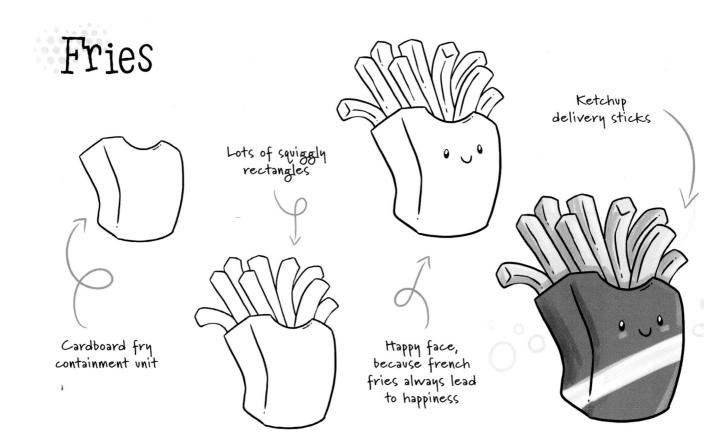

Lots of squiggly rectangles

Ketchup delivery sticks

Cardboard fry containment unit

Happy face, because french fries always lead to happiness

Hamburger

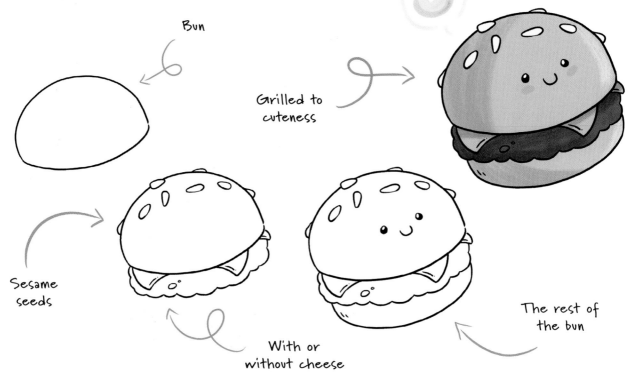

Bun

Grilled to cuteness

Sesame seeds

With or without cheese

The rest of the bun

Lasagna

Draw a box.

Add a melty top to the box.

You know, if you colored this a different way it could be tiramisu.

Cheesy layers and saucy layers

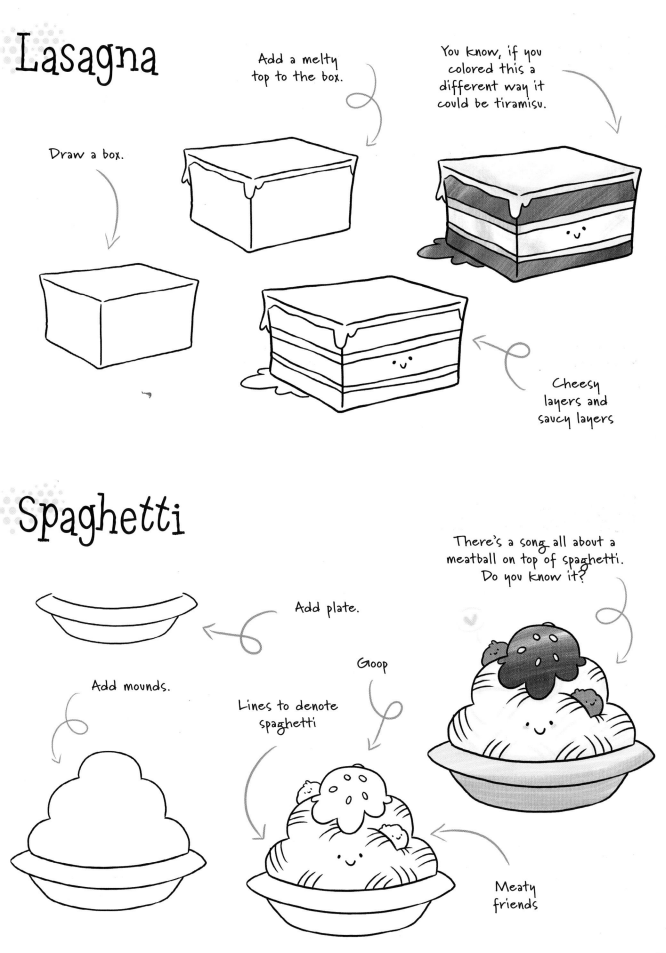

Spaghetti

Add mounds.

Add plate.

Lines to denote spaghetti

Goop

There's a song all about a meatball on top of spaghetti. Do you know it?

Meaty friends

Pizza

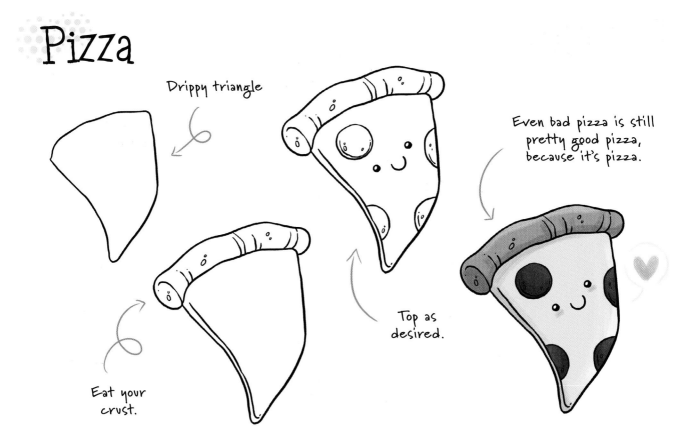

Drippy triangle

Eat your crust.

Top as desired.

Even bad pizza is still pretty good pizza, because it's pizza.

Bacon and Eggs

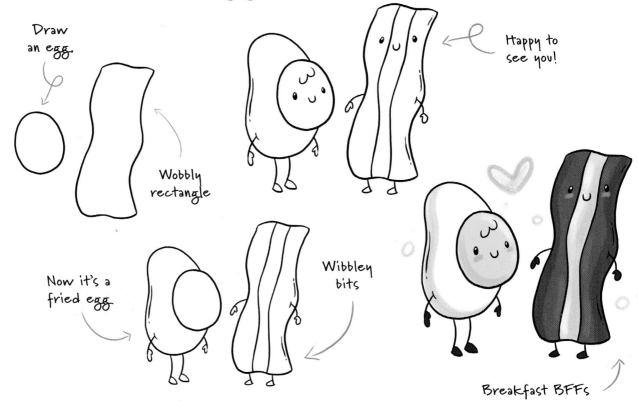

Draw an egg.

Wobbly rectangle

Now it's a fried egg

Wibbley bits

Happy to see you!

Breakfast BFFs

Burrito

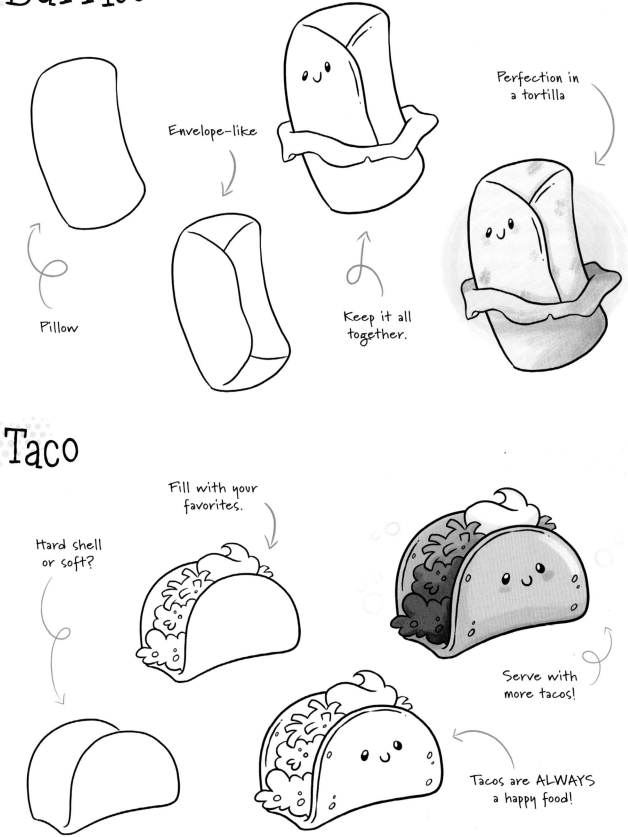

Pillow

Envelope-like

Keep it all together.

Perfection in a tortilla

Taco

Hard shell or soft?

Fill with your favorites.

Serve with more tacos!

Tacos are ALWAYS a happy food!

Banana

A potato wedge french fry. One of the more disappointing potato shapes.

Banana nub

Back it up.

They find you A-PEEL-ING! Ha!

Give them some depth. Bananas are deep thinkers.

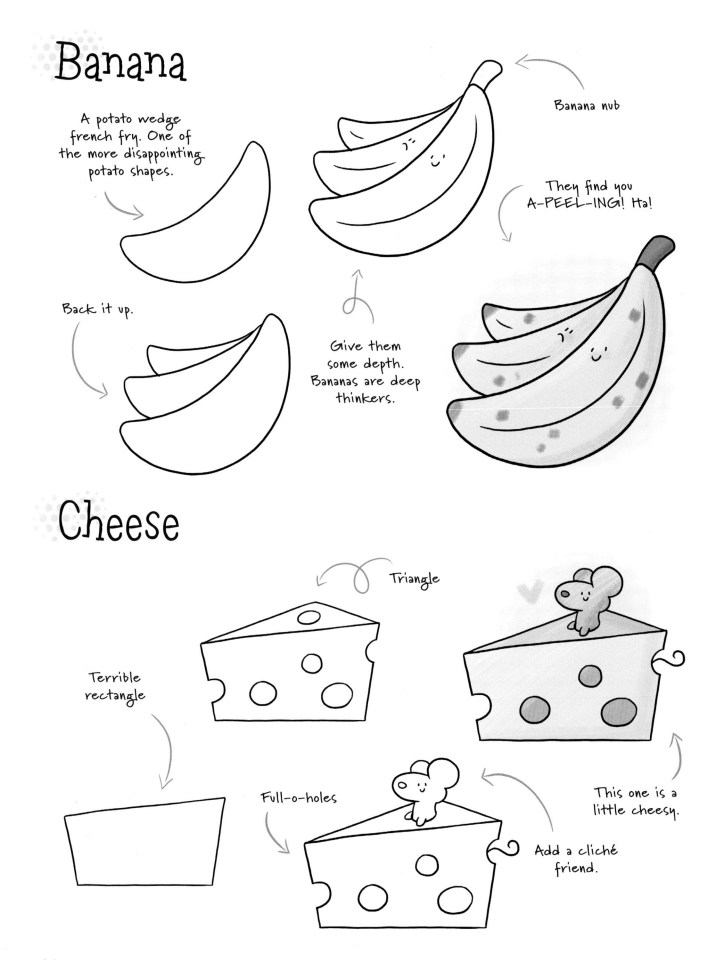

Cheese

Triangle

Terrible rectangle

Full-o-holes

This one is a little cheesy.

Add a cliché friend.

Cinnamon Roll

Squishy shape

Drippy bits

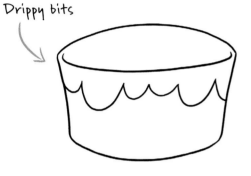

Swirly

My precious cinnamon roll

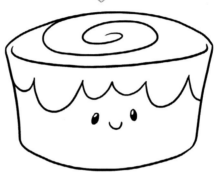

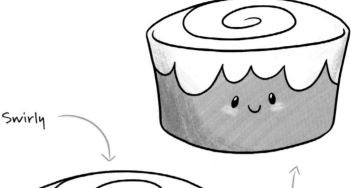

Hot Dog

Pickle

Add ketchup.

Two more consecutive pickles

I'm glad this one is in color, otherwise you'd have thought I was actually drawing pickles covered in ketchup. Ick!

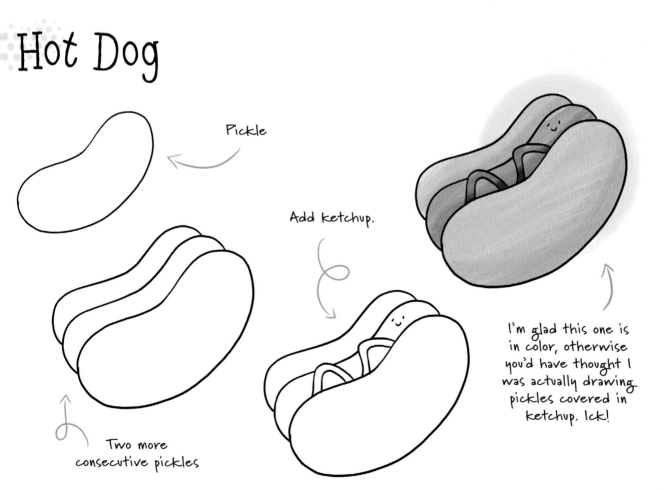

Kiwi

Draw an egg.

The good part

Add kiwi bird . . . a bird with no flap flaps. It's a real thing. I swear!

Fuzz it up.

Cut it up!

Muffin

I don't care if a muffin has things like blueberries in it. It's cakey.

See? Add frosting. Even a little=cupcake. There.

Didn't we already do this . . . no, wait, hear me out.

Really, a muffin is just a cupcake with no icing. There. I said it. Fight me!

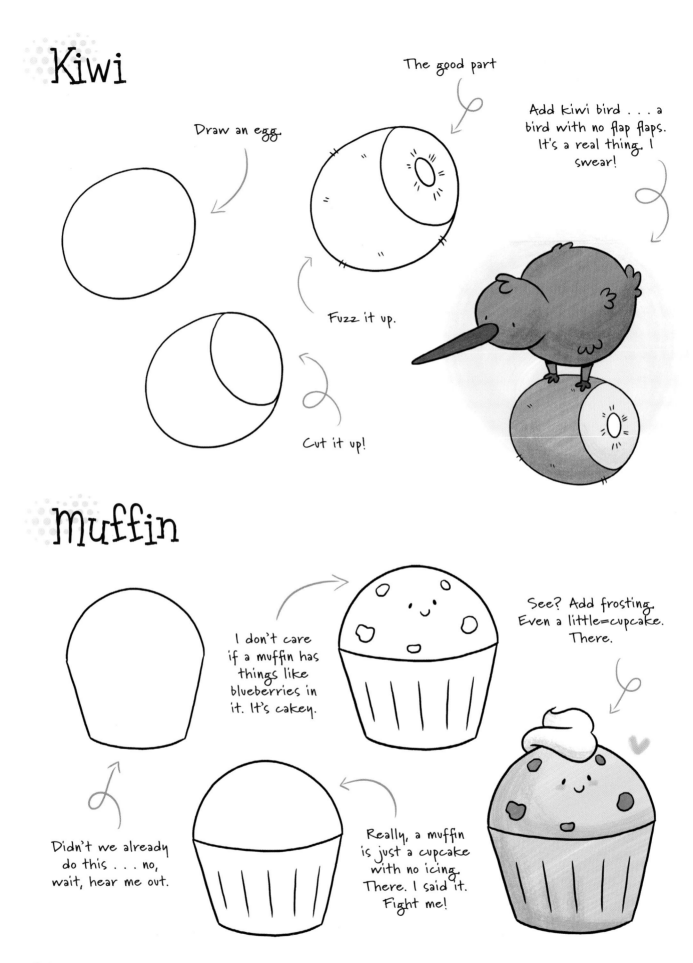

Pancake

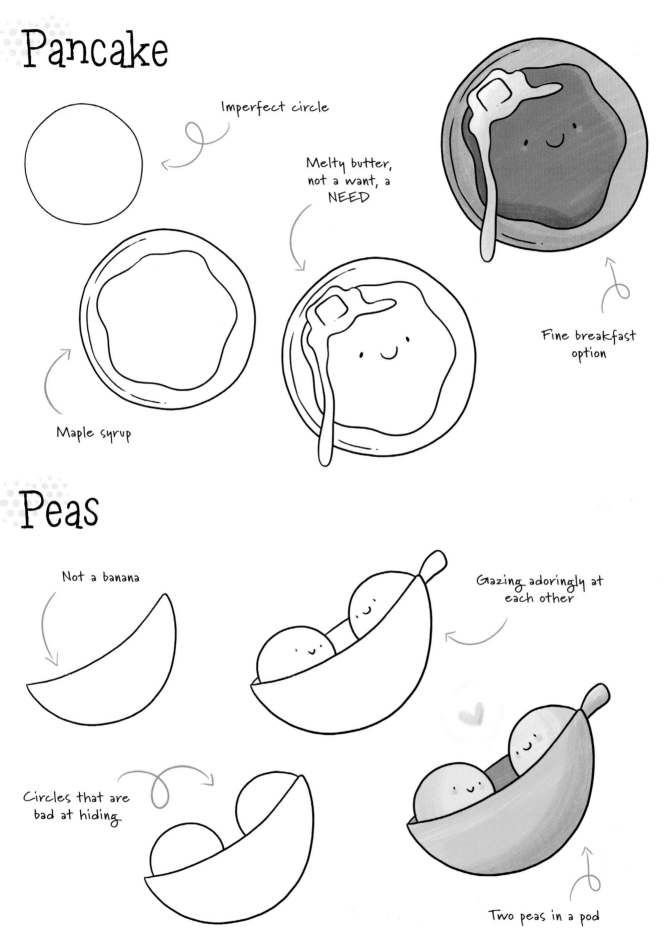

Imperfect circle

Melty butter, not a want, a NEED

Maple syrup

Fine breakfast option

Peas

Not a banana

Gazing adoringly at each other

Circles that are bad at hiding

Two peas in a pod

Popcorn

A very exciting box

Popcorn fluff

Watch out for the unpopped kernels. Next time draw them fully popped.

Exciting because it's full of fluff.

Stragglers

Toast

Draw some carbs.

Crust on, no cutting off the crusts in this house!

Toasty

Butter or jam, your choice

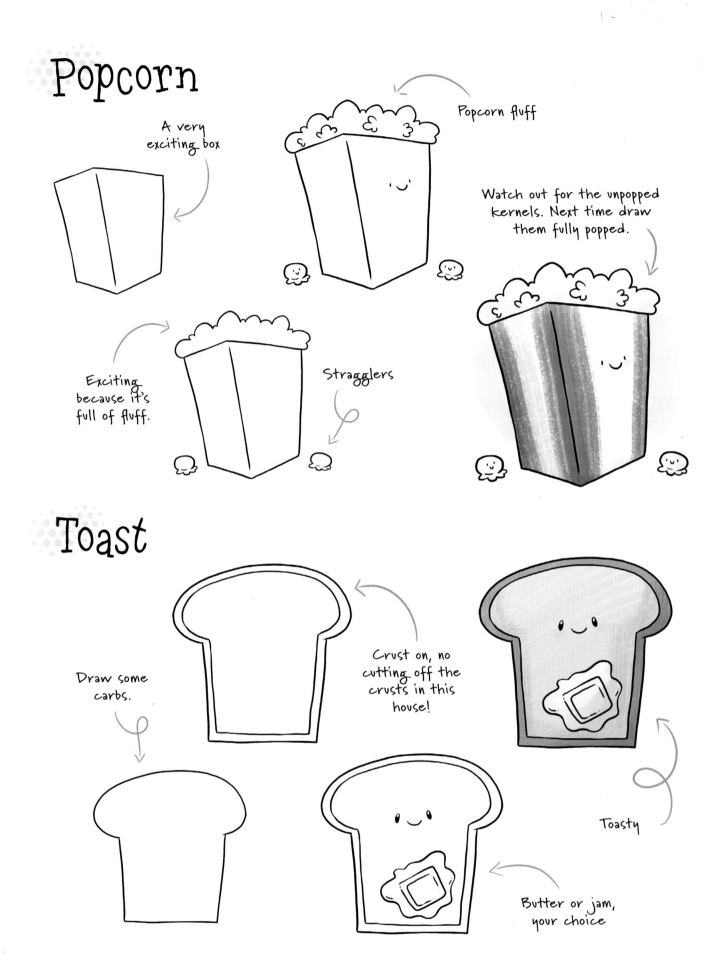

Popsicle

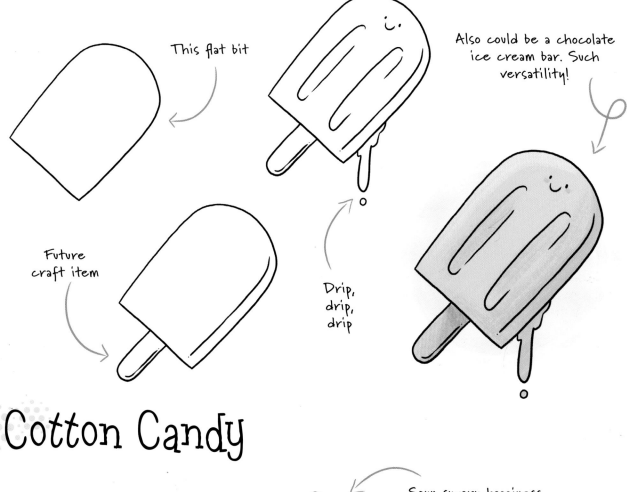

This flat bit

Future craft item

Drip, drip, drip

Also could be a chocolate ice cream bar. Such versatility!

Cotton Candy

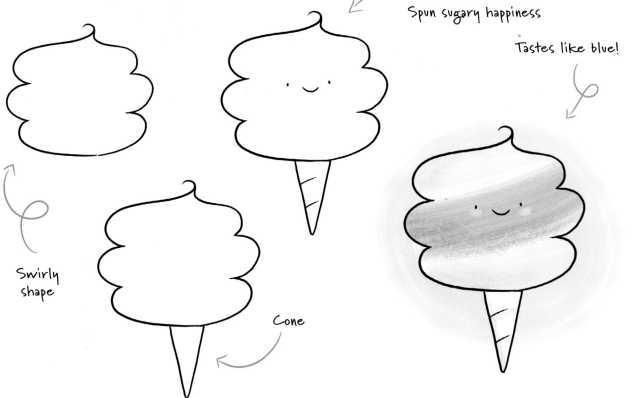

Swirly shape

Cone

Spun sugary happiness

Tastes like blue!

Hobbies and Sports

Hobbies and stuff are the best. It's the thing you do that makes you happy in your spare time. Personally, my hobby is listening to audiobooks. All the joy of reading and none of the work. I'm going to admit that my limited knowledge of sports really comes out in this chapter. I probably missed everything but the "big" ones ... um, sorry.

Yarn

Draw a ball.

Yarny bits

I'm a terrible knitter. If you can do it, pat yourself on the back for me!

Extra bit

Two knitting needles to the head. Don't worry, no yarn was hurt!

Thread

What is this, a beach towel?

Add the ouchy bit.

Oh. Thread. It's a spool. Got it.

For darning

Sew lovely

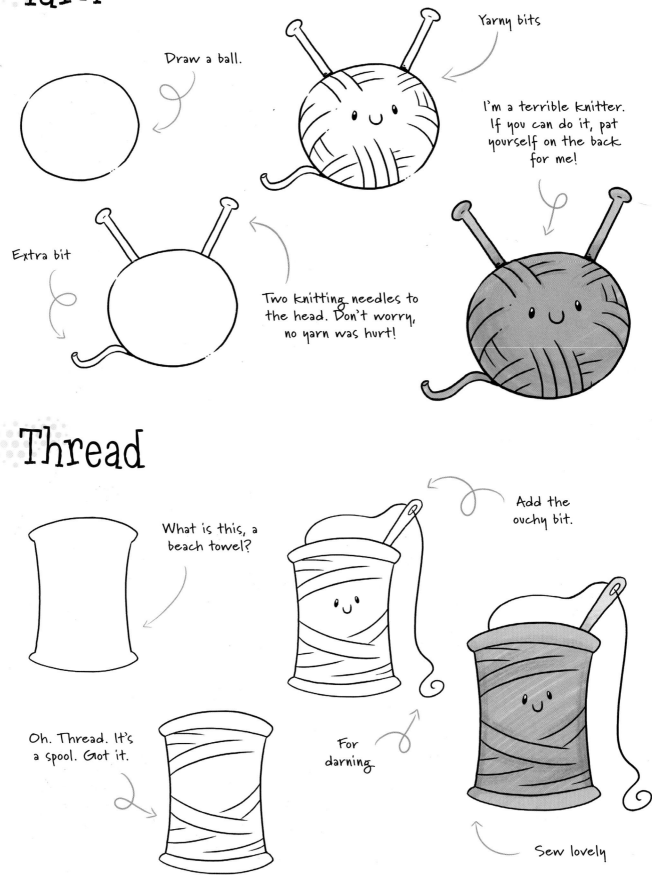

Paints

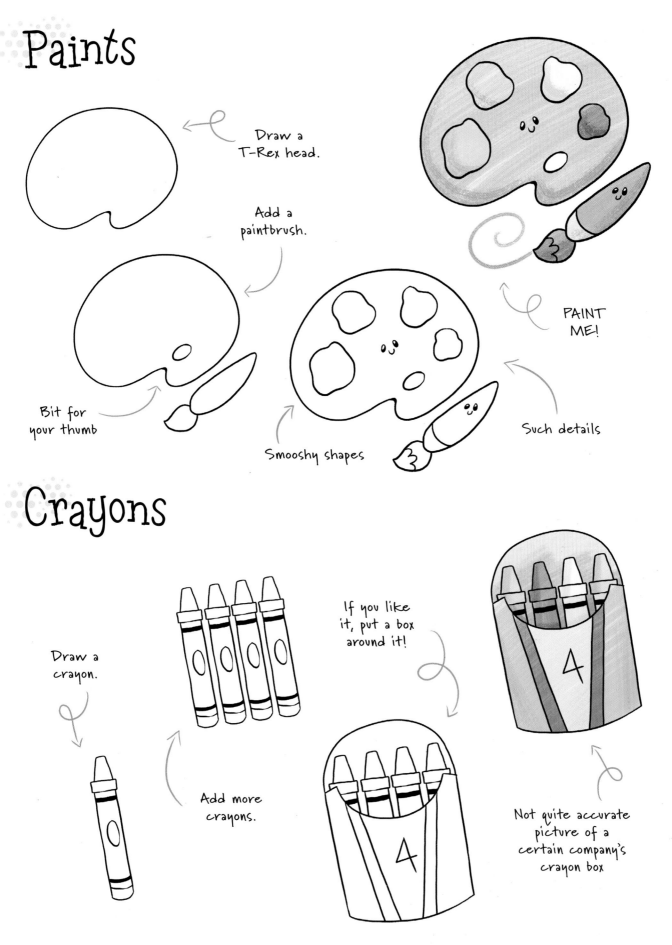

Draw a T-Rex head.

Add a paintbrush.

Bit for your thumb

Smooshy shapes

PAINT ME!

Such details

Crayons

Draw a crayon.

Add more crayons.

If you like it, put a box around it!

Not quite accurate picture of a certain company's crayon box

Puzzle

Draw a square and then add a tic-tac-toe board inside. Simple!

Add the puzzley bits to each section.

Break apart

Totally draw this on a card with "you're my missing piece" as the caption.

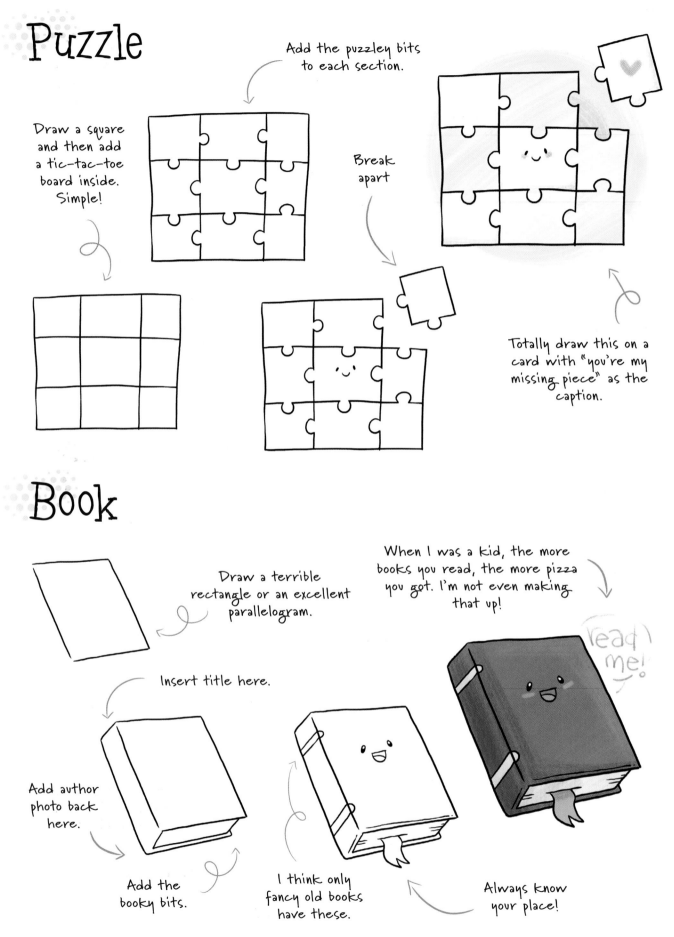

Book

Draw a terrible rectangle or an excellent parallelogram.

Insert title here.

Add author photo back here.

Add the booky bits.

When I was a kid, the more books you read, the more pizza you got. I'm not even making that up!

read me!

I think only fancy old books have these.

Always know your place!

Ballet

Draw a bean.

Add a foot hole. I don't know what it's called.

The flat toe bit

Add the important ribbon part. The longer the better.

For spinny dancing

Yoga

Burrito shape

Burrito shape extension

Swirly bit

For balance

yoga!

Seriously though, yoga is good for you. I highly recommend it!

For hydration

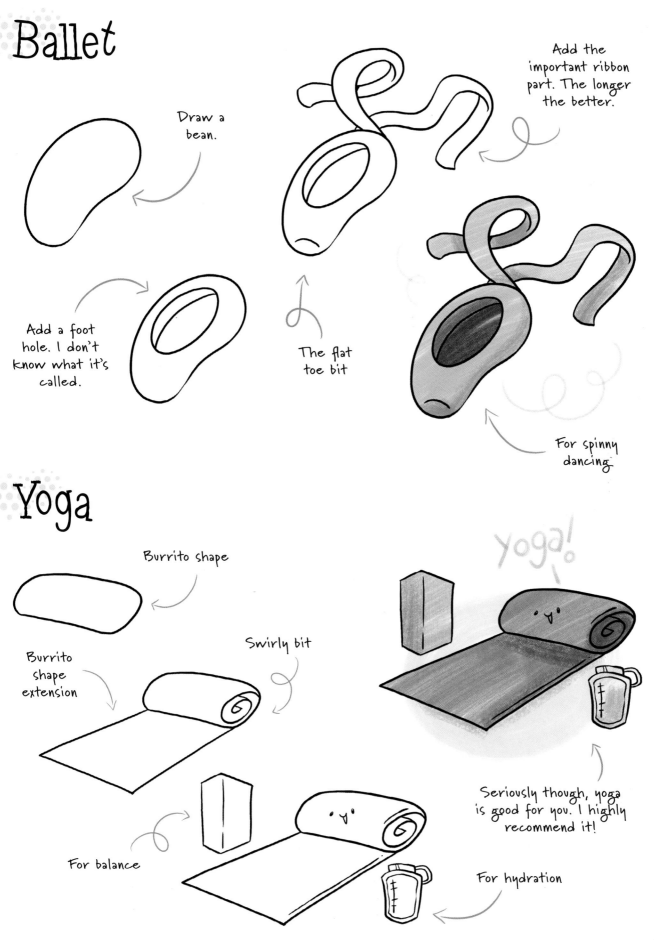

73

Ice Skates

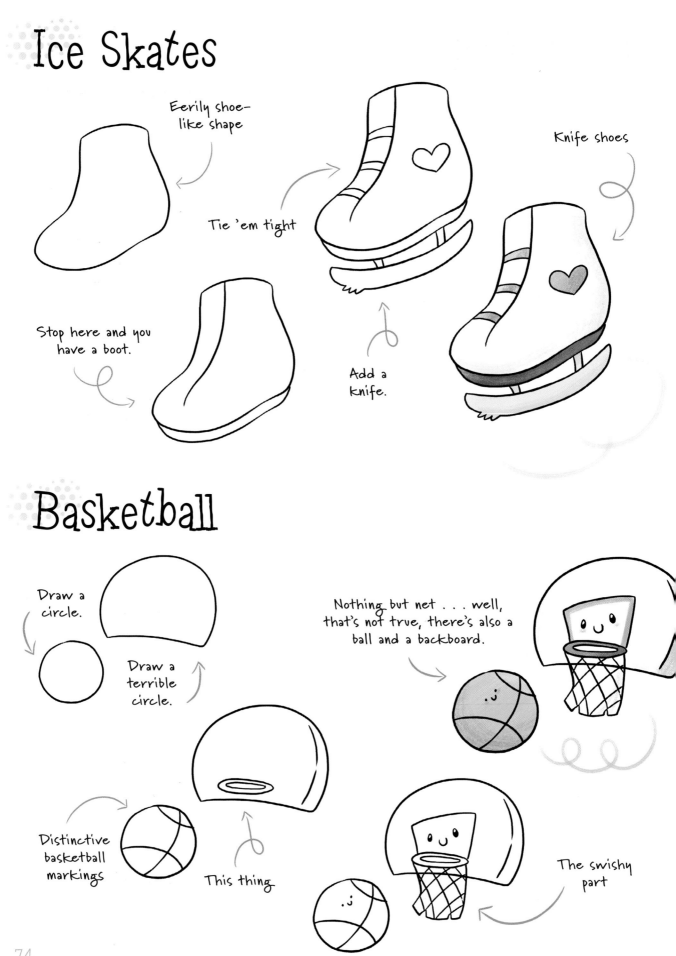

Eerily shoe-like shape

Tie 'em tight

Knife shoes

Stop here and you have a boot.

Add a knife.

Basketball

Draw a circle.

Draw a terrible circle.

Nothing but net . . . well, that's not true, there's also a ball and a backboard.

Distinctive basketball markings

This thing

The swishy part

Soccer Ball

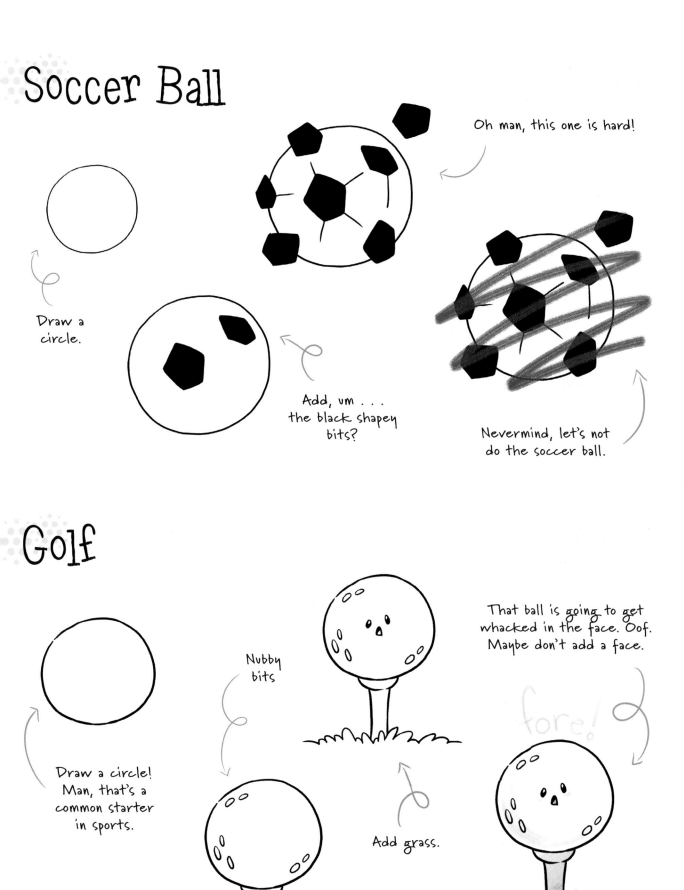

Oh man, this one is hard!

Draw a circle.

Add, um . . . the black shapey bits?

Nevermind, let's not do the soccer ball.

Golf

Oh man, this one is hard!

That ball is going to get whacked in the face. Oof. Maybe don't add a face.

Nubby bits

Draw a circle! Man, that's a common starter in sports.

May as well keep it interesting and add the tee.

Add grass.

fore!

75

Football

Draw a precise lemon.

Traditional laces . . . probably not functional anymore

That's how you know it's a football.

Hehe

KICK ME

I was once in a little fluff news story during a certain big football game. On TV and everything. I know nothing about football and flubbed trying to fake that I did. Good times.

KICK ME

Hockey

Hold here.

Not a cookie

This one makes me laugh every time I see it!

Hitty part

Draw this sports stick thing . . . Interchangeable with a golf club.

Sorry!

ow!

WHAP!

WHAP!

Action!

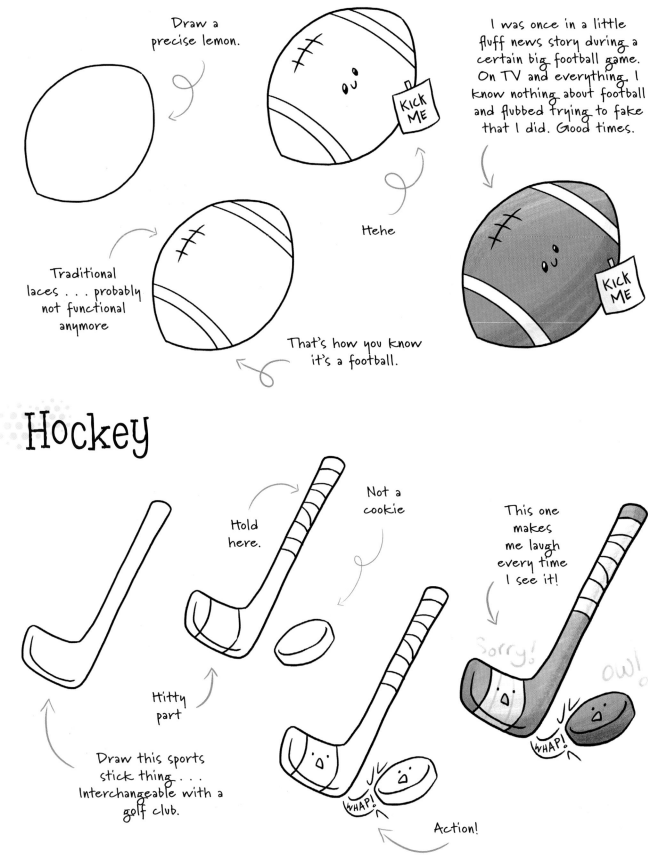

Skateboard

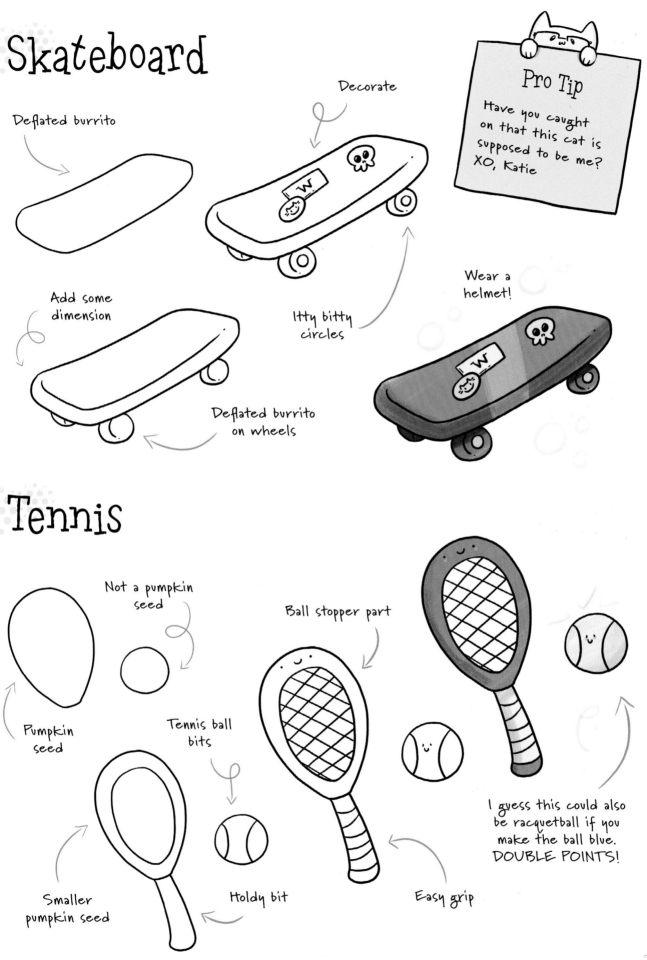

Deflated burrito

Decorate

Add some dimension

Itty bitty circles

Wear a helmet!

Deflated burrito on wheels

Tennis

Not a pumpkin seed

Ball stopper part

Pumpkin seed

Tennis ball bits

Smaller pumpkin seed

Holdy bit

Easy grip

I guess this could also be racquetball if you make the ball blue. DOUBLE POINTS!

Fishing

Draw a stick.

This bit

Add a fish.

Swimmy bits

The little X eyes really sell this one.

Fishing line

Fish likely dead

Kayak

You'll need this thing.

Draw a surfboard.

Every kayak is red . . . probably.

But AH! It's not a surfboard. HA!

It's a kayak. Says so in the title.

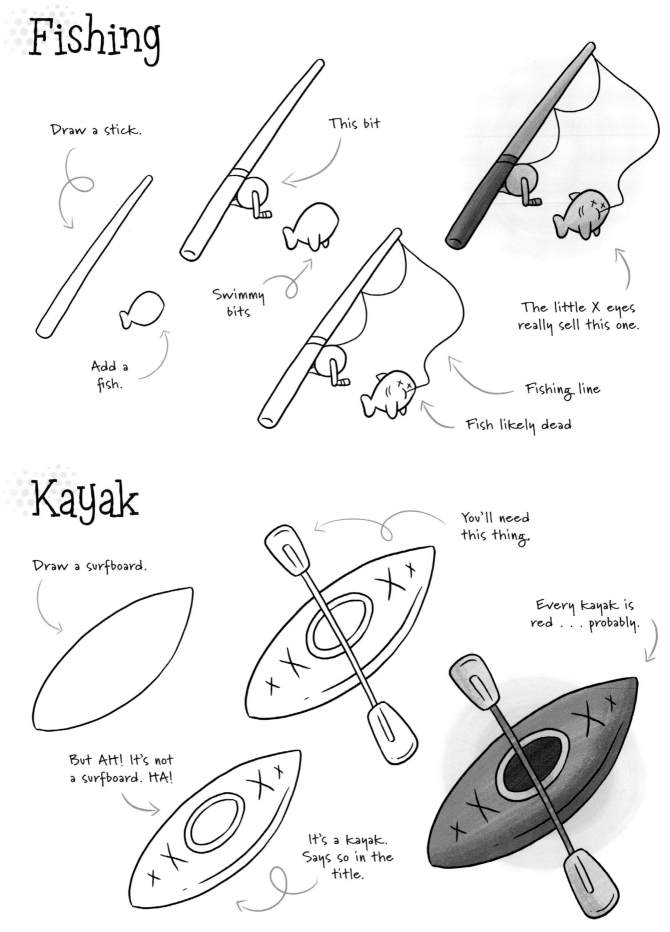

Surfing

Draw a surfboard . . . wait, isn't that how I started the last one?

Decorate as you see fit.

I would probably be terrible at surfing. I don't even need to try it. I just know.

Ah, that's right, that other one was a kayak. It didn't have this thing.

Racecar

Bar of soap

For style

For speed

Vrooooom

The glass bit

Add donuts.

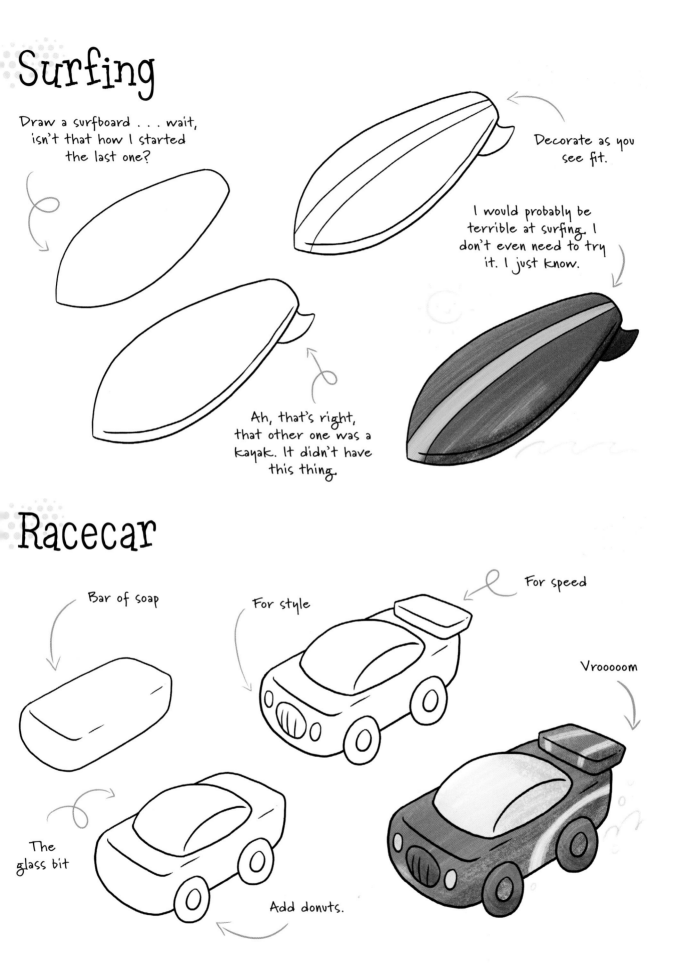

Badminton

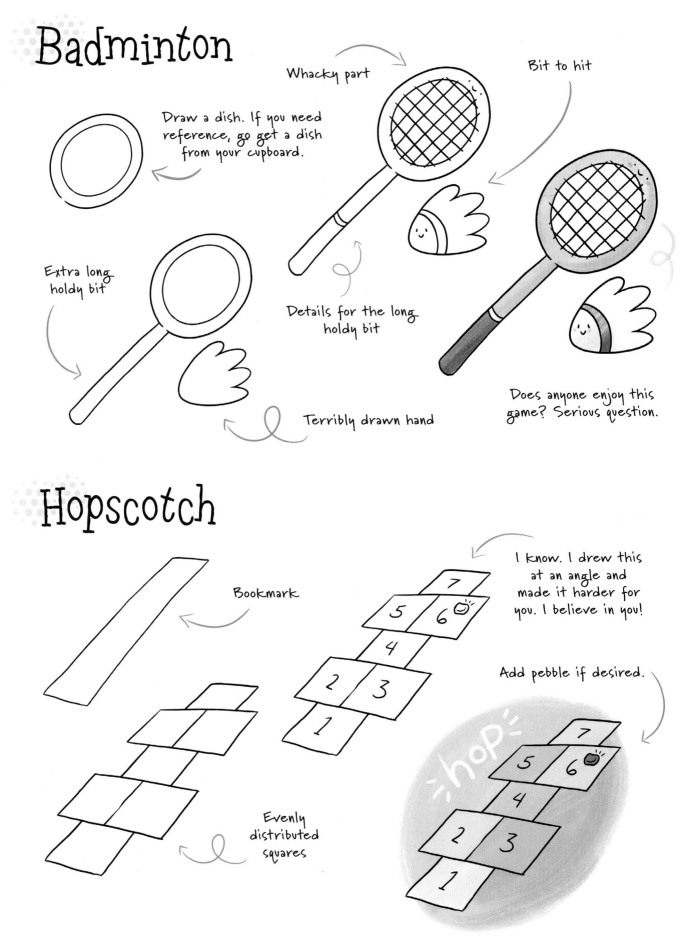

Whacky part

Bit to hit

Draw a dish. If you need reference, go get a dish from your cupboard.

Extra long holdy bit

Details for the long holdy bit

Terribly drawn hand

Does anyone enjoy this game? Serious question.

Hopscotch

Bookmark

I know. I drew this at an angle and made it harder for you. I believe in you!

Add pebble if desired.

Evenly distributed squares

hop

Croquet

Tin can

I bet you're so good at circles by now.

Add stick

Terrified look

This is how you score, I think.

Stick details

WHAP!

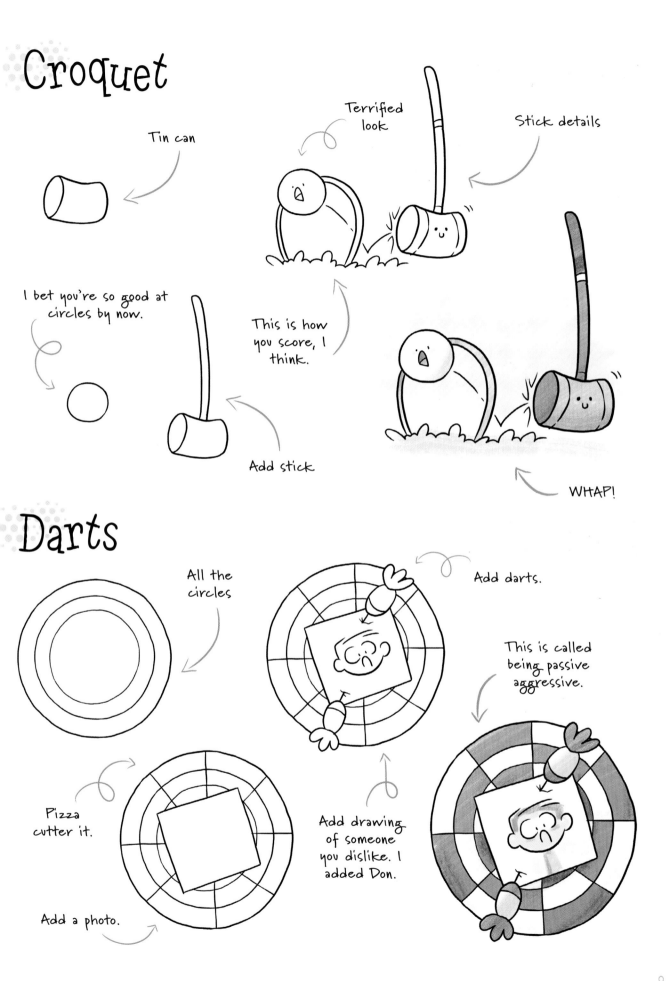

Darts

All the circles

Pizza cutter it.

Add a photo.

Add drawing of someone you dislike. I added Don.

Add darts.

This is called being passive aggressive.

Guitar

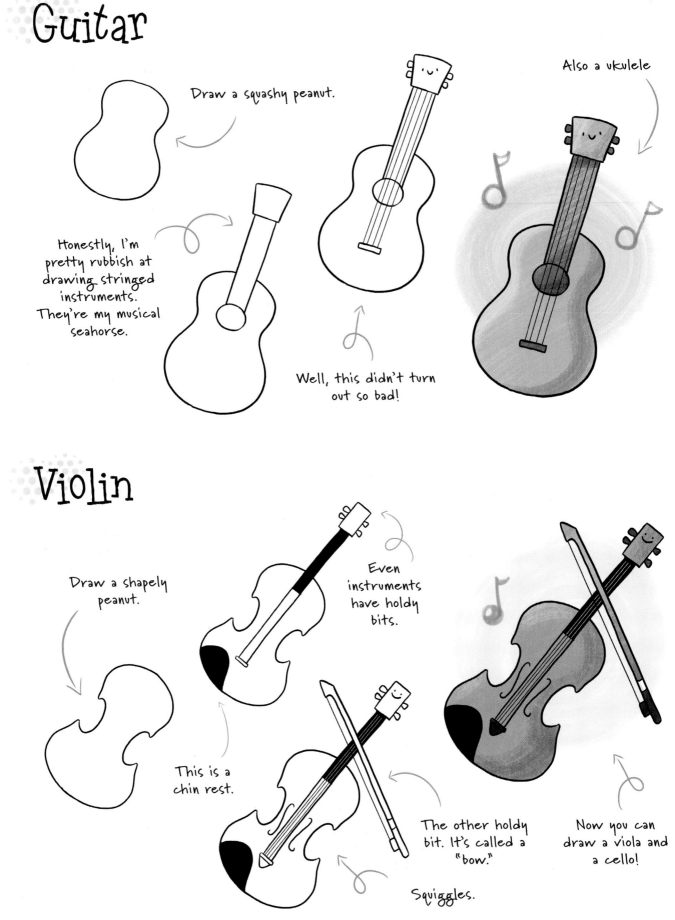

Draw a squashy peanut.

Also a ukulele

Honestly, I'm pretty rubbish at drawing stringed instruments. They're my musical seahorse.

Well, this didn't turn out so bad!

Violin

Draw a shapely peanut.

Even instruments have holdy bits.

This is a chin rest.

The other holdy bit. It's called a "bow."

Now you can draw a viola and a cello!

Squiggles.

Tent

Draw a bed sheet fluttering in the wind.

Triangle

For support

Add a bright, bright, sun shiny day.

More sticks

Keep it grounded.

Magnifying Glass

Draw a hula hoop.

Add a big bit of caterpillar.

Do not angle the sun at the bug in the way we all know you're thinking. NO!

Add a small bit of caterpillar.

I bet you thought I was going to call this something weird, didn't you? It's just a handle.

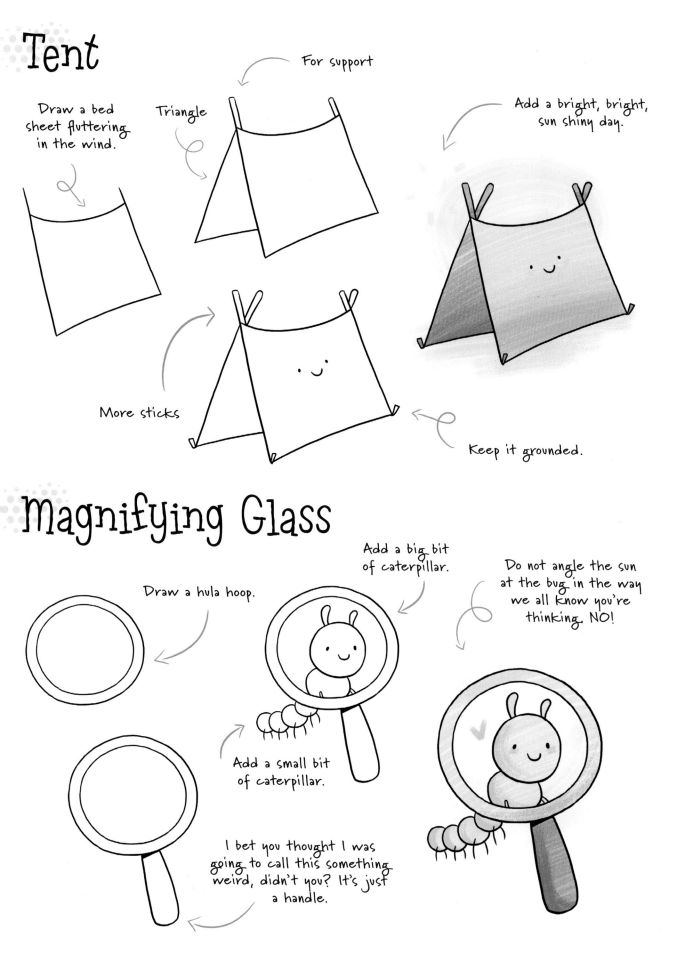

Film Camera

Two circles. Two. Count 'em.

The filmy bit

Or are *these* the filmy bit? They contain film but the other parts film it?

Add a rectangle. Deceptively simple

Stability bits

Perfect for your movie night invitations. Just add popcorn!

Video Game Controller

Lima bean

Do these things still have cords?

More buttons

This bit here

Add buttons to lima bean.

Play away!

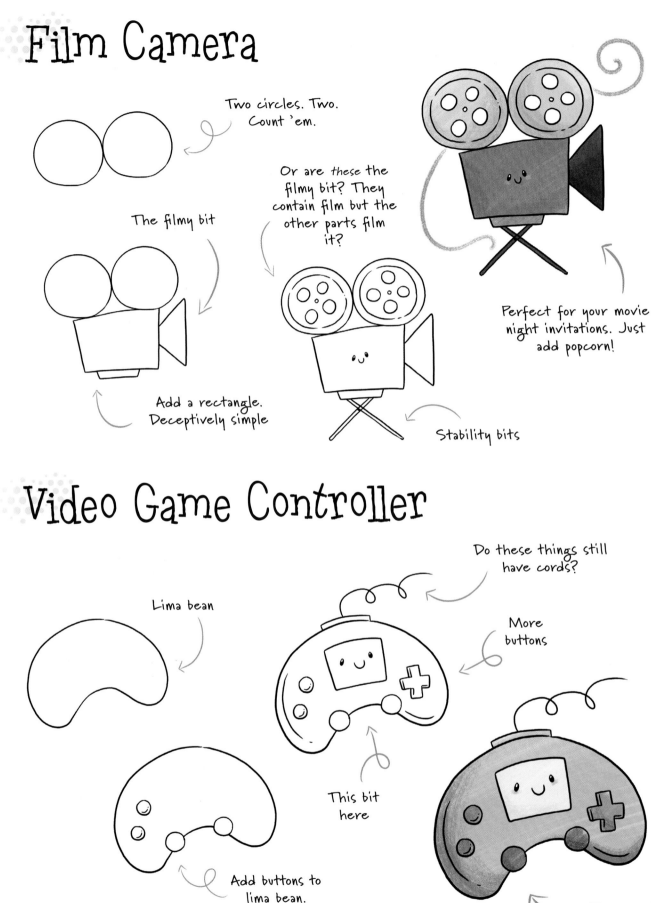

Watering Can

Draw a very unexciting
wastepaper basket.

This is kind of what defines
it as a watering can,
otherwise it's just a bucket.

Then add a
handle.

For setting
the scene

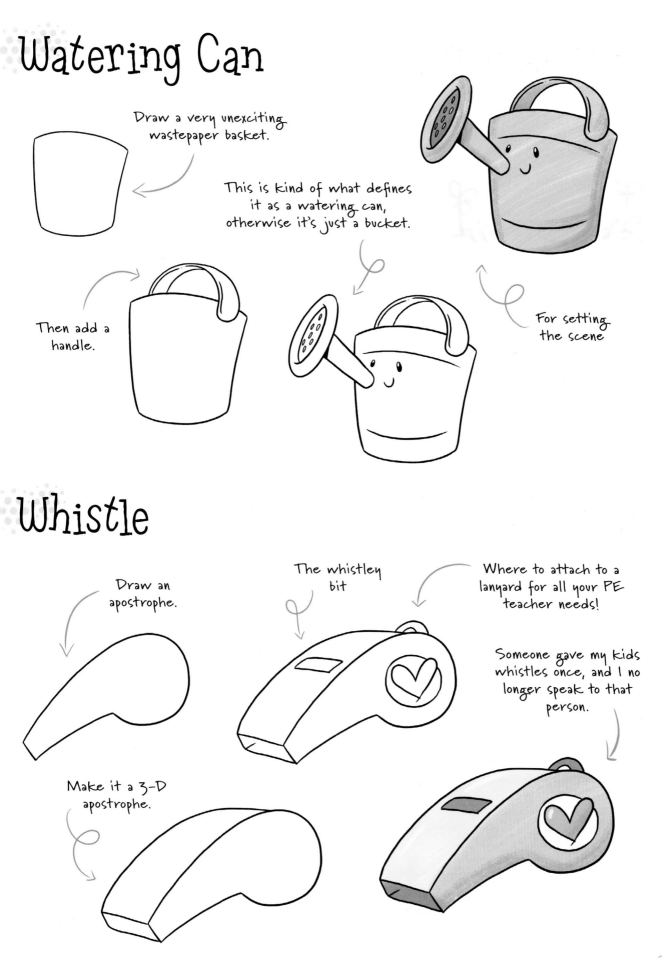

Whistle

Draw an
apostrophe.

The whistley
bit

Where to attach to a
lanyard for all your PE
teacher needs!

Someone gave my kids
whistles once, and I no
longer speak to that
person.

Make it a 3-D
apostrophe.

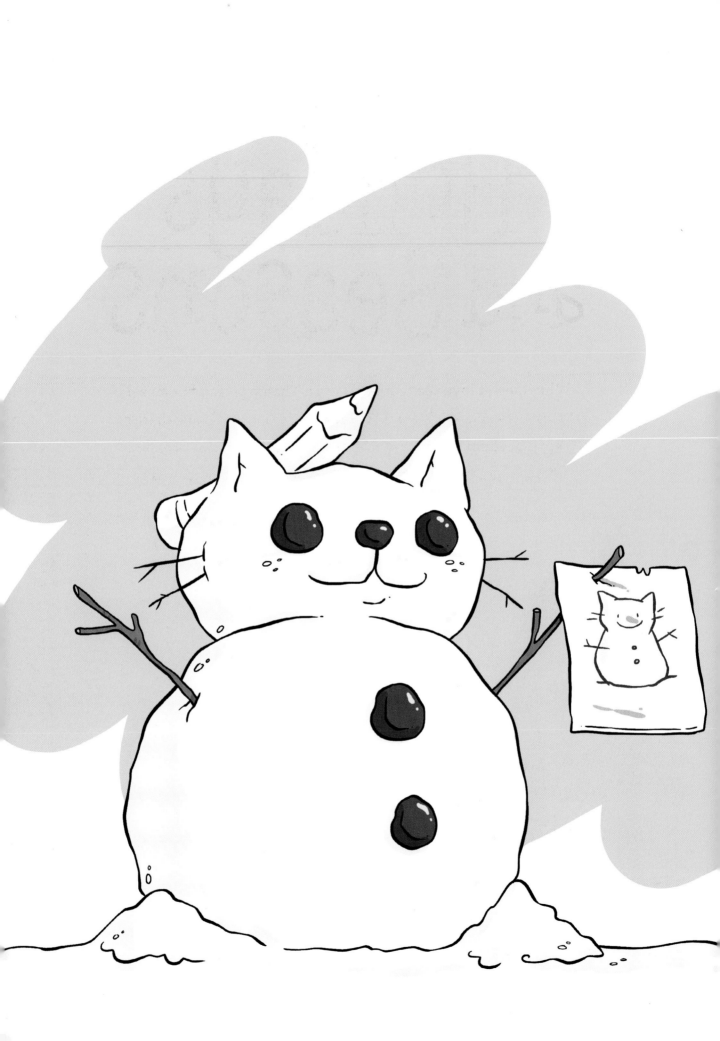

CHAPTER 4

Holidays and Seasons

Who doesn't love the holidays? I'm a Thanksgiving fan myself, mostly because I like pie. As far as seasons go, I know there's spring, summer, fall and winter . . . but I live in a state called "Michigan" and we specialize in winter 'round these parts.

Snowman

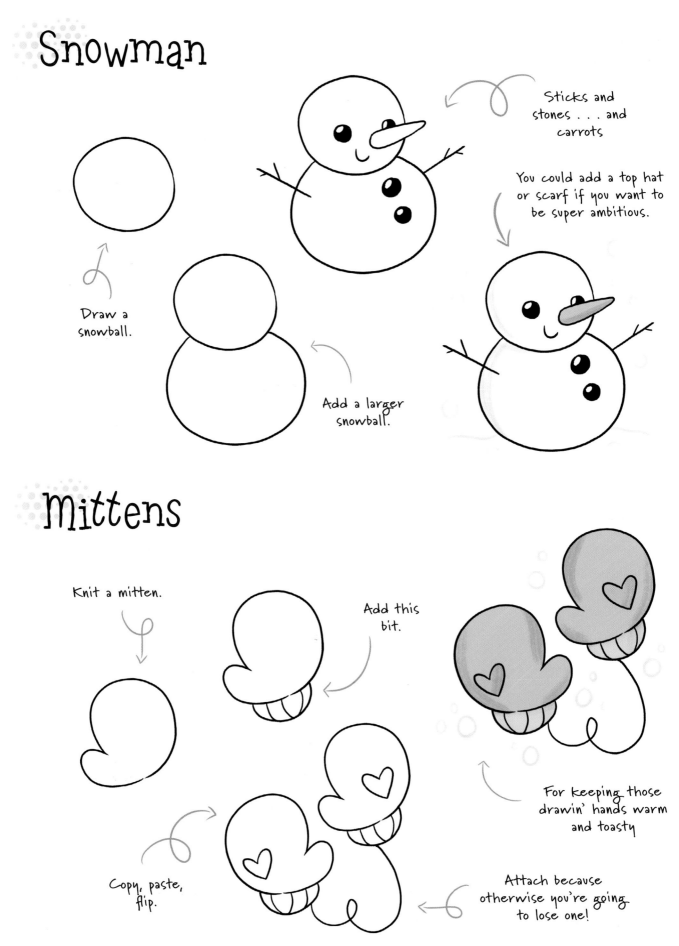

Draw a snowball.

Add a larger snowball.

Sticks and stones . . . and carrots

You could add a top hat or scarf if you want to be super ambitious.

Mittens

Knit a mitten.

Add this bit.

Copy, paste, flip.

For keeping those drawin' hands warm and toasty

Attach because otherwise you're going to lose one!

Wreath

Decorate

Decorate more

So festive

Draw
a fluffy
circle.

Add a smaller
fluffy circle.

Holly

Draw a berry.

Add more
berries.

Did you know
holly is toxic?

Pro Tip

Don't eat it!
No, really. I
mean it. Don't
eat it.

Leaves

Christmas Tree

If you stop here you just have a plain ol' evergreen tree.

Top that off

But if you keep going it's a CHRISTMAS TREE!

Oh, Christmas Tree . . .

Menorah

Start with a candle and candle holder.

Even more candles . . . There, that'll do it.

We're going to need more candles!

Lovely, isn't it?

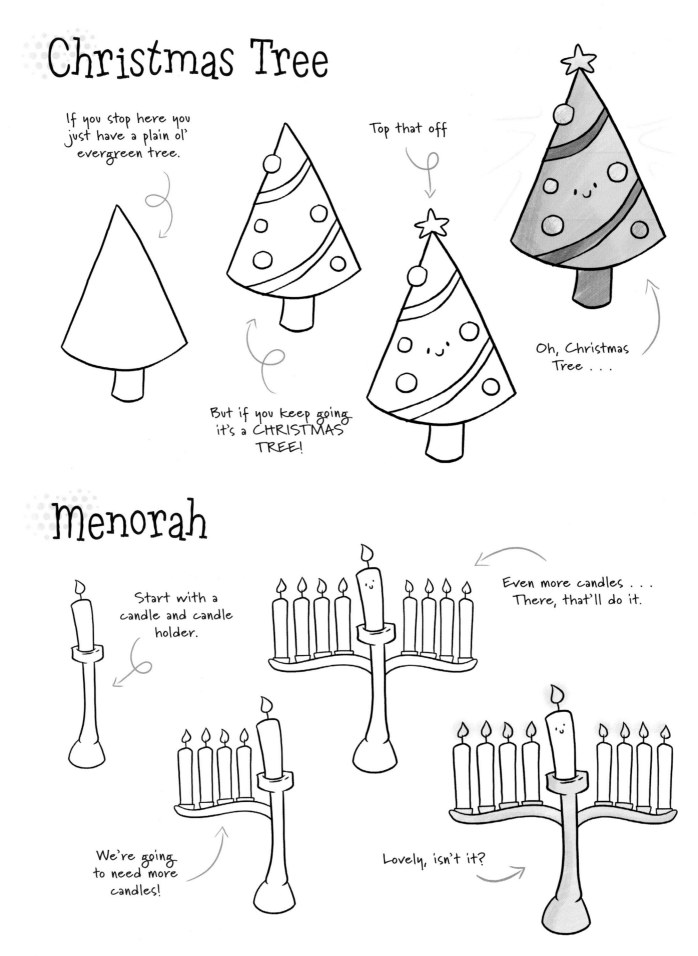

Reindeer

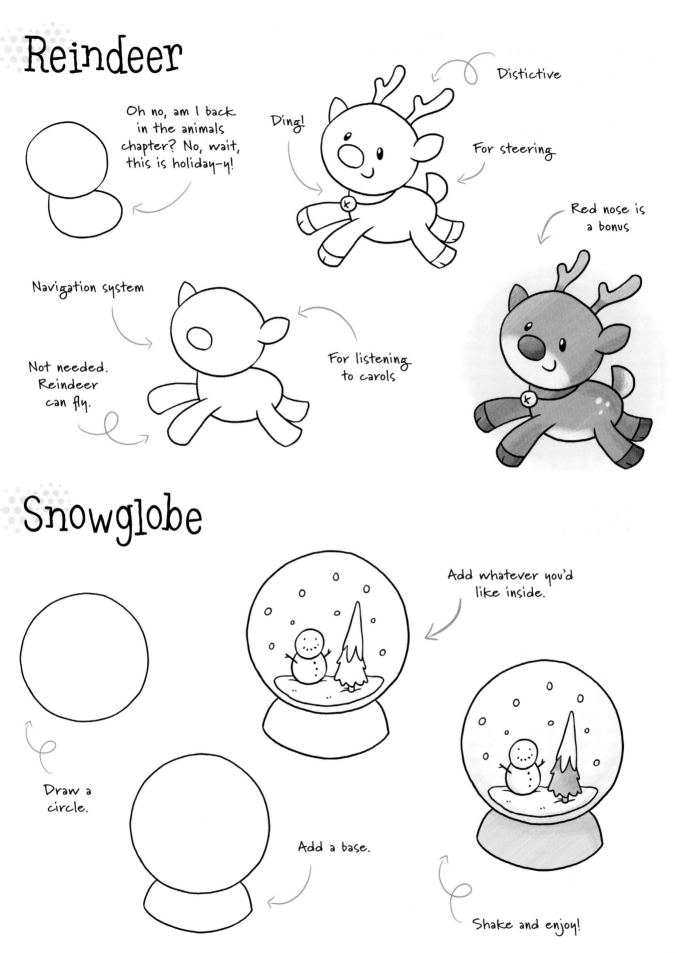

Oh no, am I back in the animals chapter? No, wait, this is holiday-y!

Ding!

Distictive

For steering

Navigation system

Not needed. Reindeer can fly.

For listening to carols

Red nose is a bonus

Snowglobe

Add whatever you'd like inside.

Draw a circle.

Add a base.

Shake and enjoy!

Gingerbread

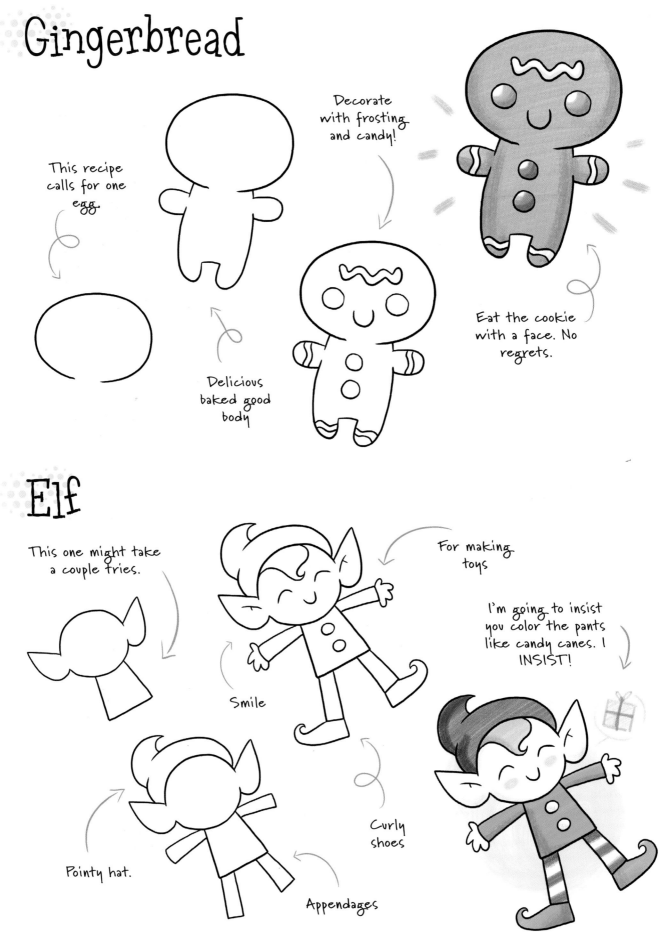

This recipe calls for one egg.

Decorate with frosting and candy!

Delicious baked good body

Eat the cookie with a face. No regrets.

Elf

This one might take a couple tries.

For making toys

Smile

Curly shoes

Pointy hat.

Appendages

I'm going to insist you color the pants like candy canes. I INSIST!

Clouds

Draw a cloud. There. You're done!

. . . or happy

Or you could keep going and make the cloud mad.

. . . or SUPER mad

Umbrella

A regular ol' C will do here.

Bottom of a bat wing

Make it rain.

And this

You will need this part.

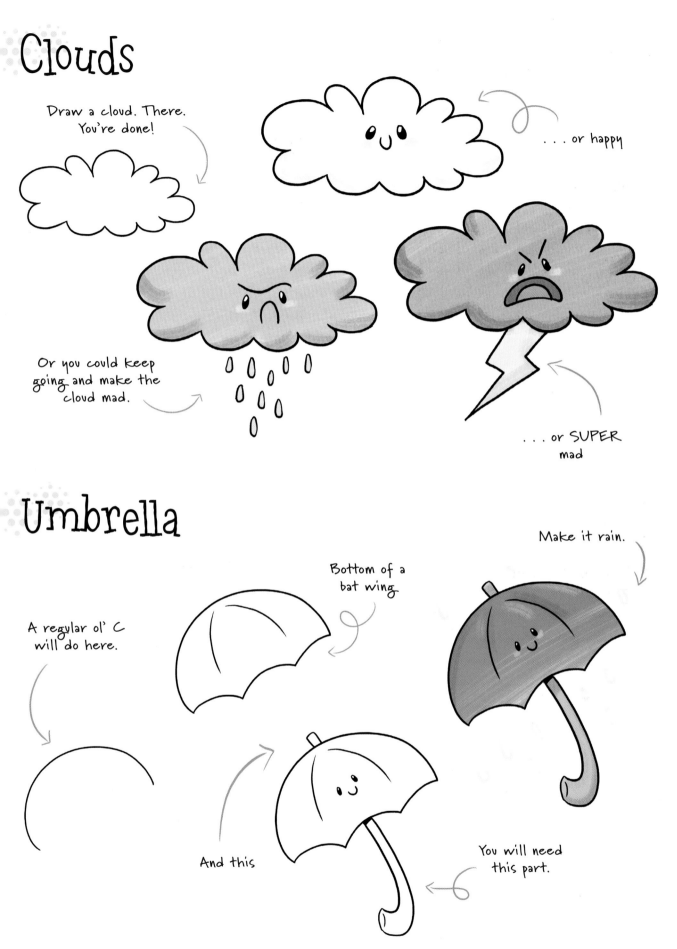

Candy Heart

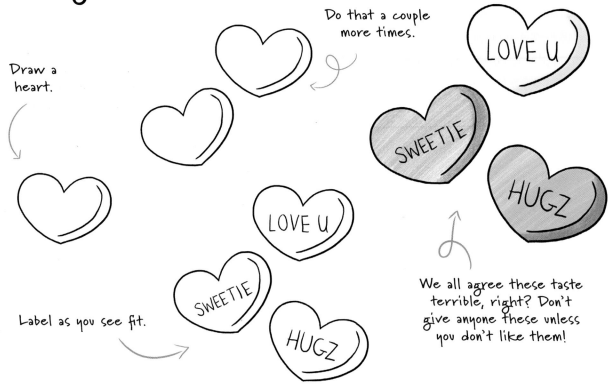

Draw a heart.

Do that a couple more times.

LOVE U

SWEETIE

HUGZ

Label as you see fit.

LOVE U

SWEETIE

HUGZ

We all agree these taste terrible, right? Don't give anyone these unless you don't like them!

Rose

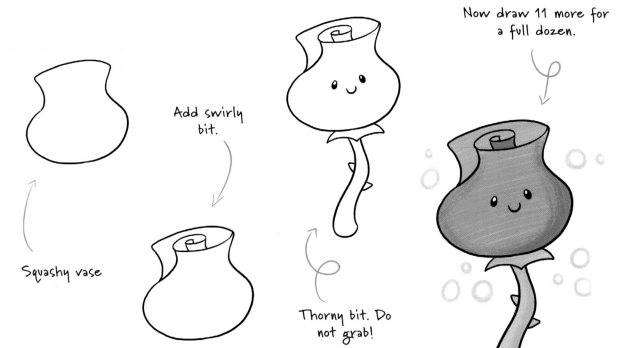

Now draw 11 more for a full dozen.

Add swirly bit.

Squashy vase

Thorny bit. Do not grab!

Daisy

This is going to be the part bees like.

You can add more than 5. Go crazy!

Stem and a leaf

Daises are the happiest of all the flowers. Science says so.

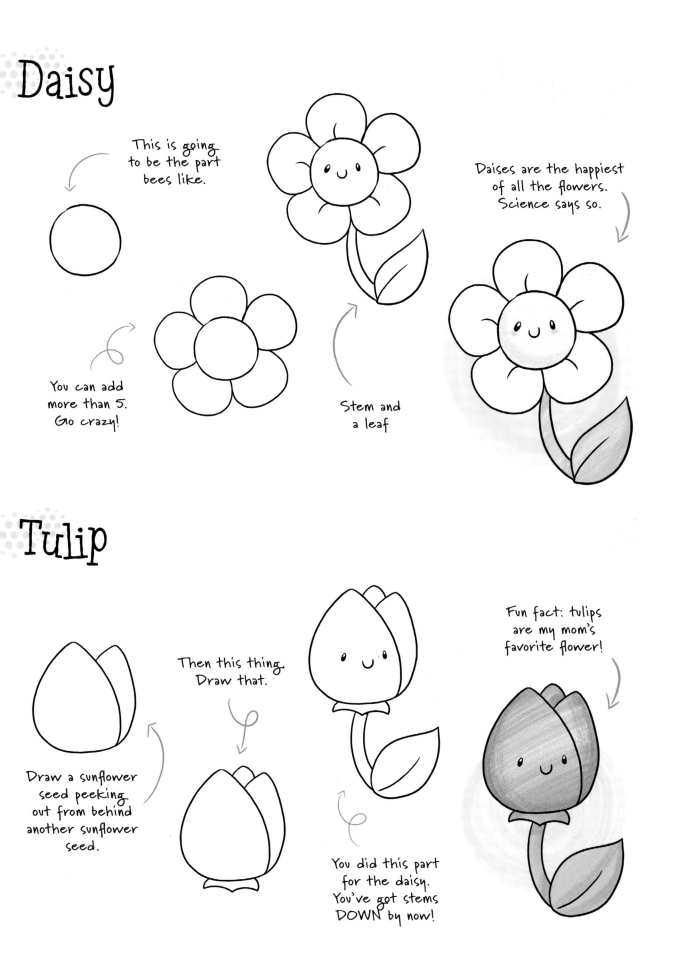

Tulip

Then this thing. Draw that.

Draw a sunflower seed peeking out from behind another sunflower seed.

You did this part for the daisy. You've got stems DOWN by now!

Fun fact: tulips are my mom's favorite flower!

Hatching

Break an egg.

Add this alien-like creature.

Not a hat

Oh, wait, it's a bird!

Add color for +10 to adorableness!

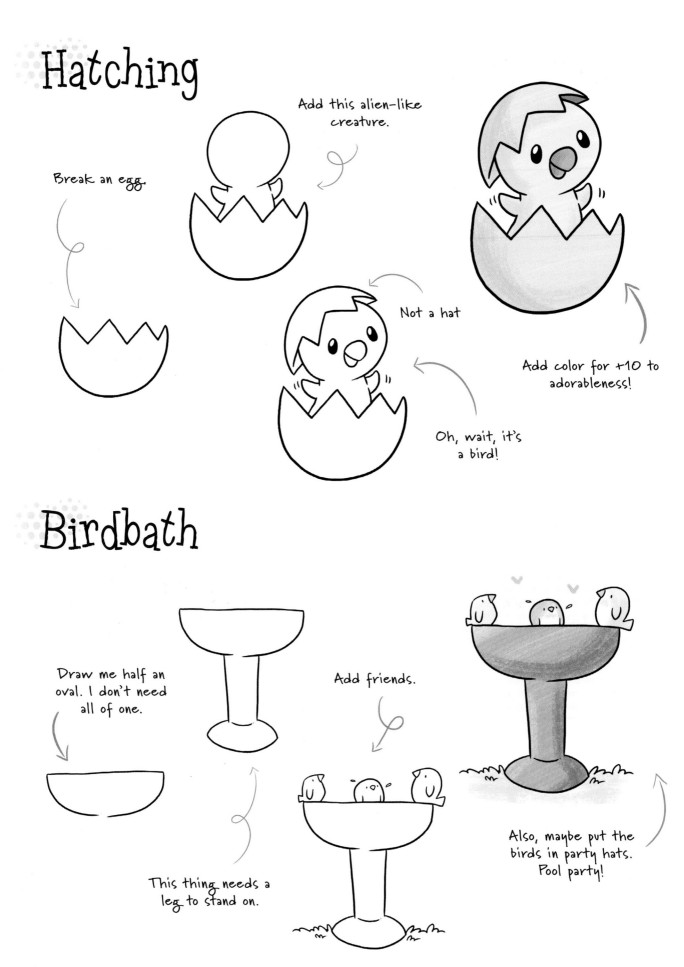

Birdbath

Draw me half an oval. I don't need all of one.

This thing needs a leg to stand on.

Add friends.

Also, maybe put the birds in party hats. Pool party!

Easter Basket

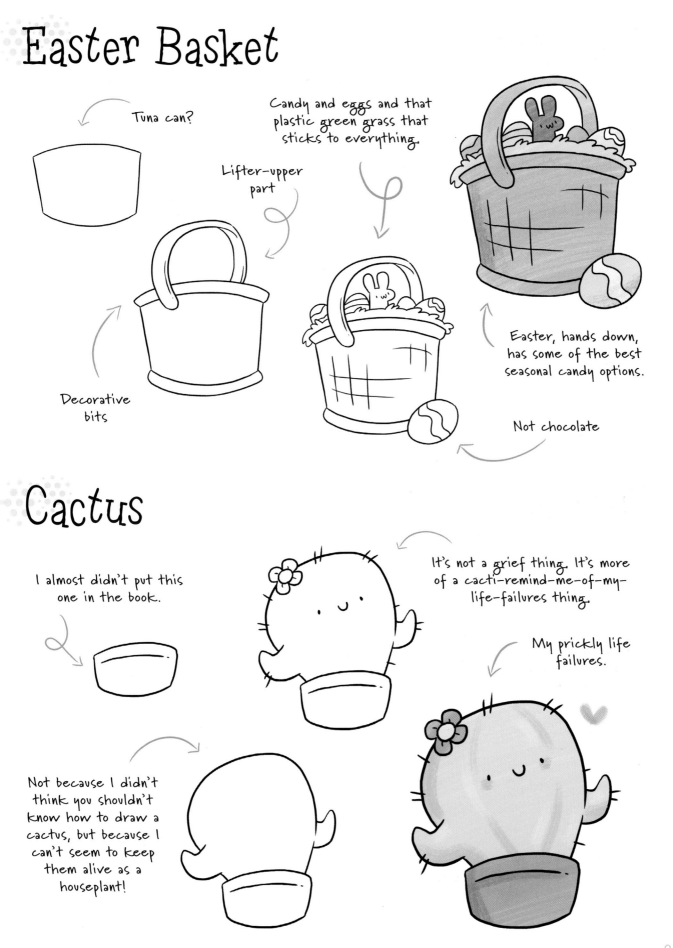

Tuna can?

Candy and eggs and that plastic green grass that sticks to everything.

Lifter-upper part

Decorative bits

Easter, hands down, has some of the best seasonal candy options.

Not chocolate

Cactus

I almost didn't put this one in the book.

It's not a grief thing. It's more of a cacti-remind-me-of-my-life-failures thing.

My prickly life failures.

Not because I didn't think you shouldn't know how to draw a cactus, but because I can't seem to keep them alive as a houseplant!

Sun

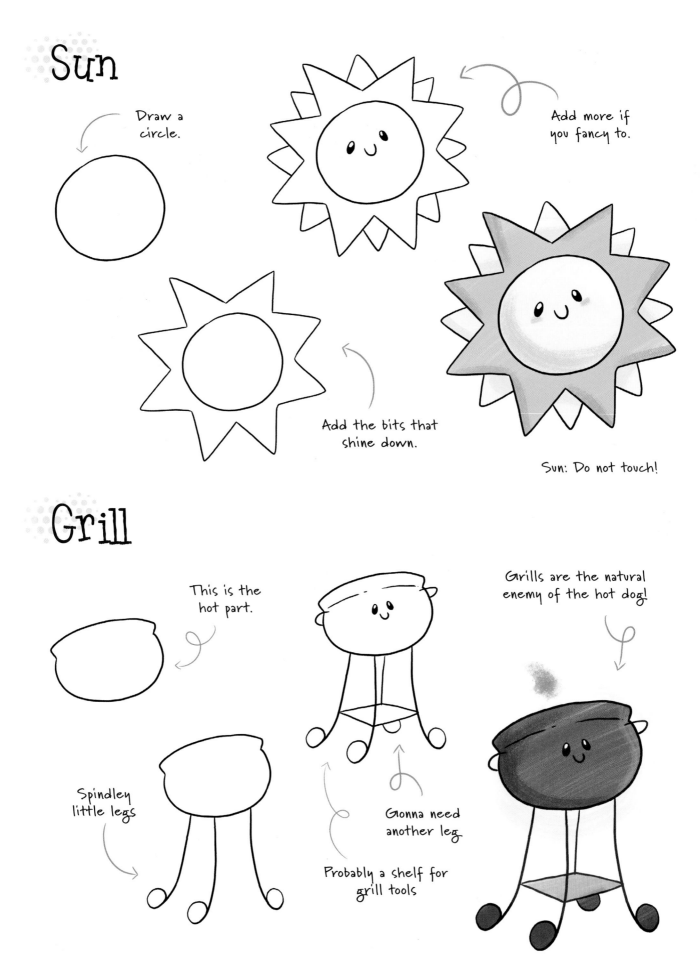

Draw a circle.

Add more if you fancy to.

Add the bits that shine down.

Sun: Do not touch!

Grill

This is the hot part.

Spindley little legs

Probably a shelf for grill tools

Gonna need another leg

Grills are the natural enemy of the hot dog!

Balloon

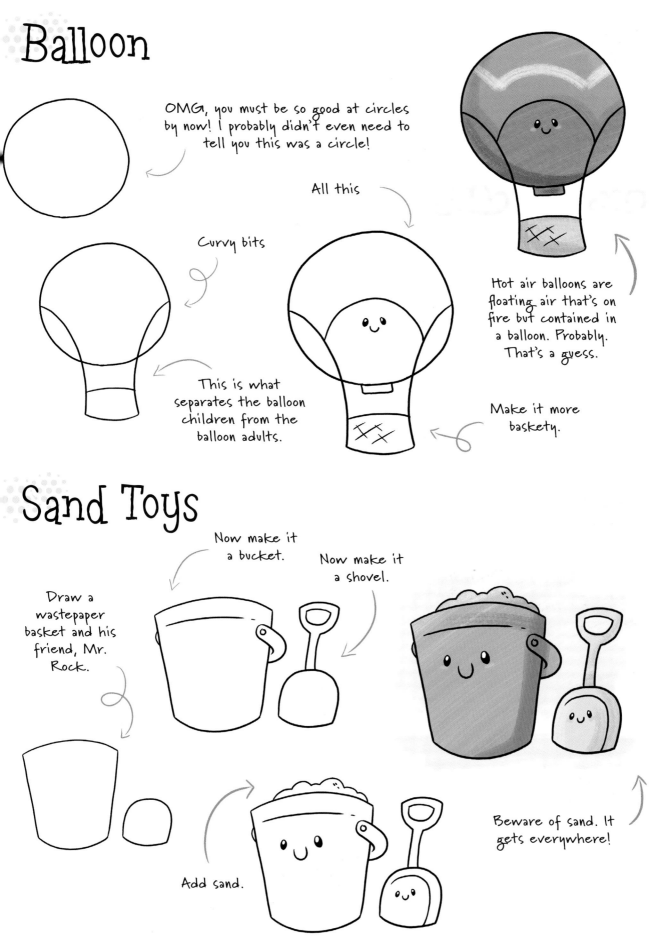

OMG, you must be so good at circles by now! I probably didn't even need to tell you this was a circle!

Curvy bits

All this

This is what separates the balloon children from the balloon adults.

Make it more baskety.

Hot air balloons are floating air that's on fire but contained in a balloon. Probably. That's a guess.

Sand Toys

Draw a wastepaper basket and his friend, Mr. Rock.

Now make it a bucket.

Now make it a shovel.

Add sand.

Beware of sand. It gets everywhere!

Sandcastle

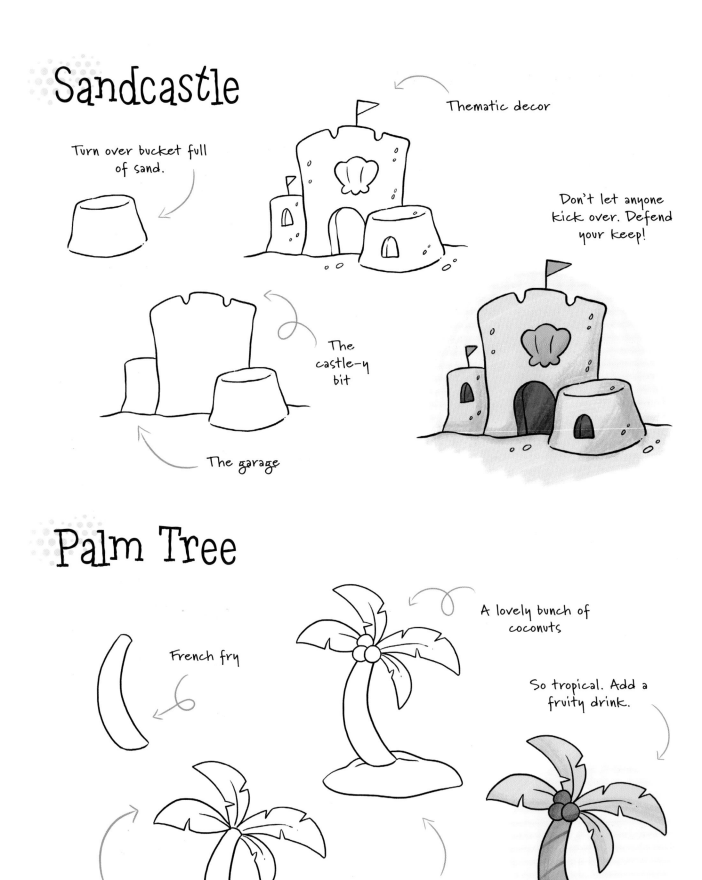

Turn over bucket full of sand.

Thematic decor

Don't let anyone kick over. Defend your keep!

The castle-y bit

The garage

Palm Tree

French fry

A lovely bunch of coconuts

So tropical. Add a fruity drink.

Fronds

Deserted island

Sunscreen Bottle

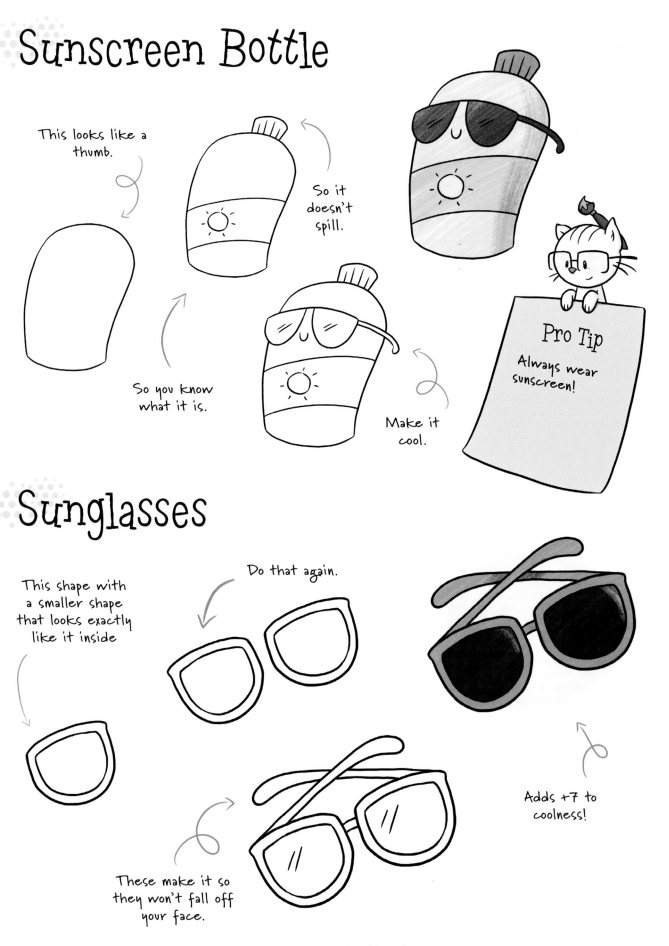

This looks like a thumb.

So it doesn't spill.

So you know what it is.

Make it cool.

Pro Tip

Always wear sunscreen!

Sunglasses

This shape with a smaller shape that looks exactly like it inside

Do that again.

These make it so they won't fall off your face.

Adds +7 to coolness!

Mum Flower

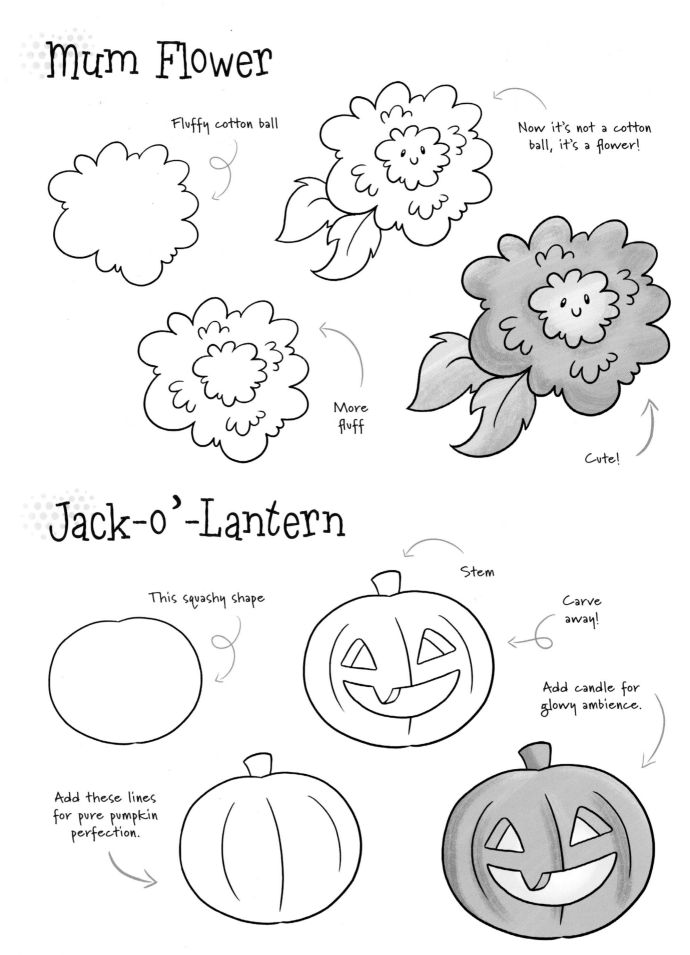

Fluffy cotton ball

Now it's not a cotton ball, it's a flower!

More fluff

Cute!

Jack-o'-Lantern

This squashy shape

Stem

Carve away!

Add candle for glowy ambience.

Add these lines for pure pumpkin perfection.

Campfire

Draw some rigatoni.

Give him a buddy.

eep!

Set on fire!

Make rigatoni more log like.

They are actually not buddies.

eep!

Bat

Oval

Ears and a widdle bat face

Flying oval

Only can be drawn at night.

Acorn

Oh man, this is going to make drawing a squirrel so much easier!

Ta da!

Me too, acorn, me too.

i fear squirrels

Squirrels do not eat this bit.

Candy Corn

There is no way this one needs 4 steps.

. . . or you could keep going

. . . and make it sad.

no one likes me

You're pretty much done here!

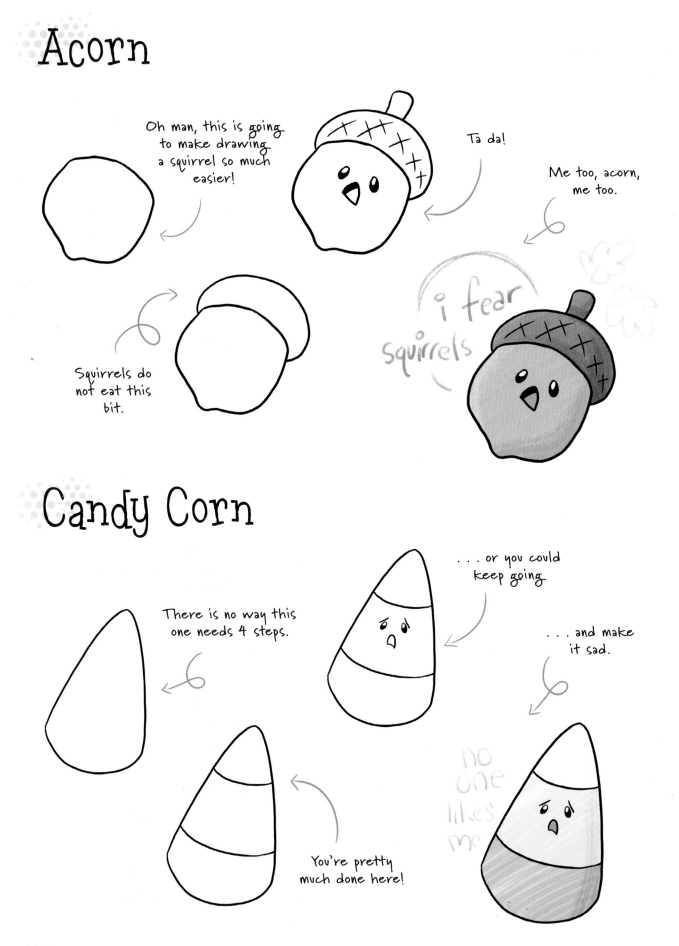

Ghost

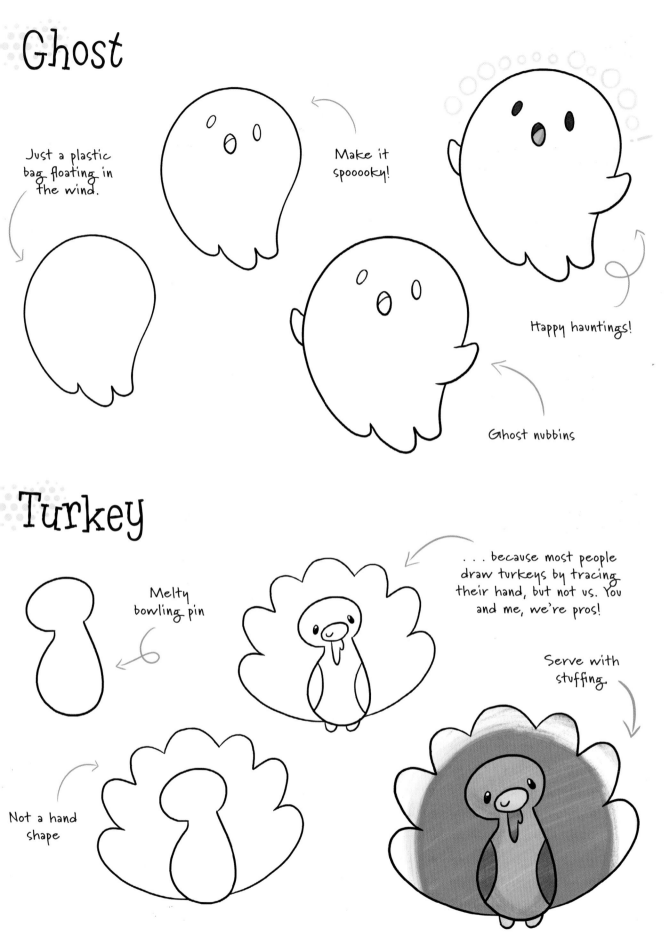

Just a plastic bag floating in the wind.

Make it spooooky!

Happy hauntings!

Ghost nubbins

Turkey

Melty bowling pin

Not a hand shape

. . . because most people draw turkeys by tracing their hand, but not us. You and me, we're pros!

Serve with stuffing.

Handy Dandy Objects

The chapter is like the garage sale of "How to Draw." The kitchen junk drawer of learning. Let's all hop into this one with an open mind and remember that even if you don't want to learn how to draw a hammer* someone out there might.

*There is not a demo for drawing a hammer.**

Well, now that I've said that maybe I should add one.*

Did I add it?*

****We won't know until you turn the page. That's called a "cliffhanger."

Robot

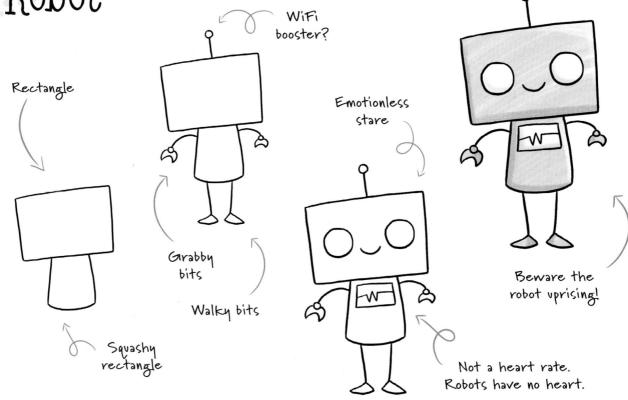

Rectangle

Squashy rectangle

WiFi booster?

Grabby bits

Walky bits

Emotionless stare

Not a heart rate. Robots have no heart.

Beware the robot uprising!

Alarm Clock

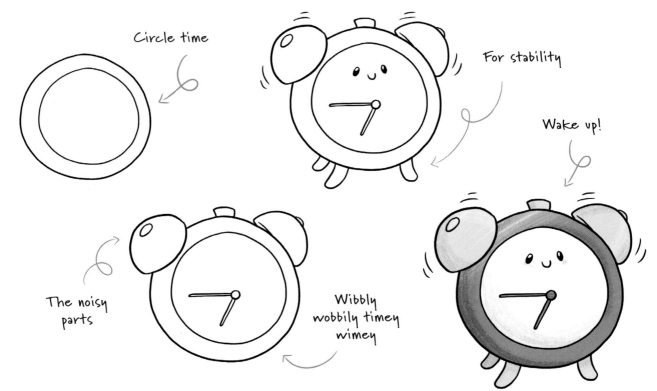

Circle time

For stability

Wake up!

The noisy parts

Wibbly wobbily timey wimey

Phone

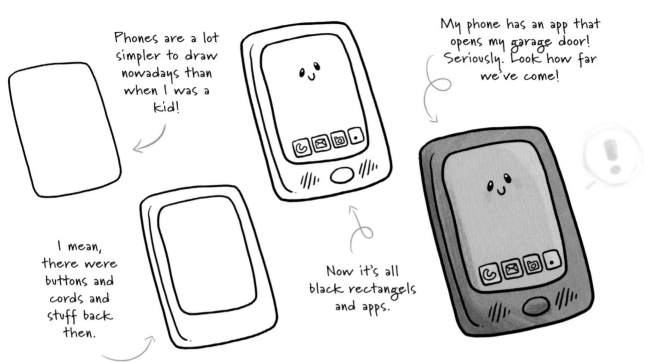

Phones are a lot simpler to draw nowadays than when I was a kid!

I mean, there were buttons and cords and stuff back then.

Now it's all black rectangels and apps.

My phone has an app that opens my garage door! Seriously. Look how far we've come!

Headphones

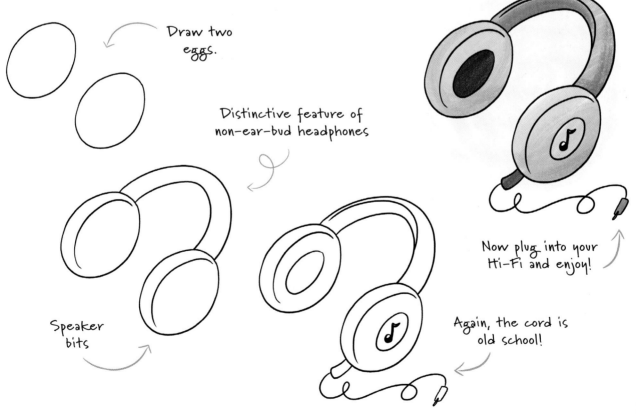

Draw two eggs.

Distinctive feature of non-ear-bud headphones

Speaker bits

Again, the cord is old school!

Now plug into your Hi-Fi and enjoy!

Laptop

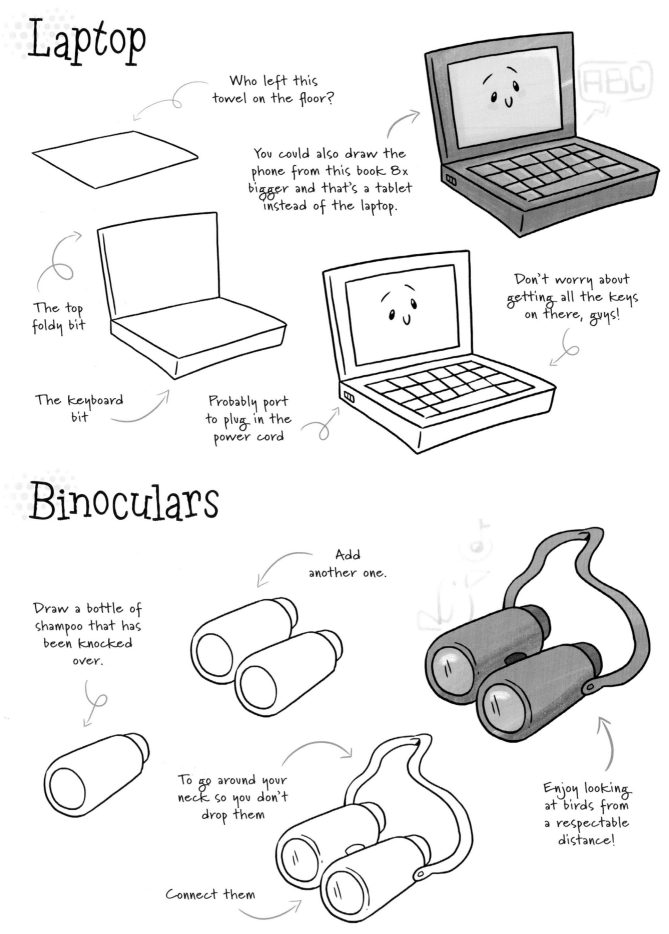

Who left this towel on the floor?

You could also draw the phone from this book 8x bigger and that's a tablet instead of the laptop.

The top foldy bit

The keyboard bit

Probably port to plug in the power cord

Don't worry about getting all the keys on there, guys!

Binoculars

Draw a bottle of shampoo that has been knocked over.

Add another one.

To go around your neck so you don't drop them

Connect them

Enjoy looking at birds from a respectable distance!

Calculator

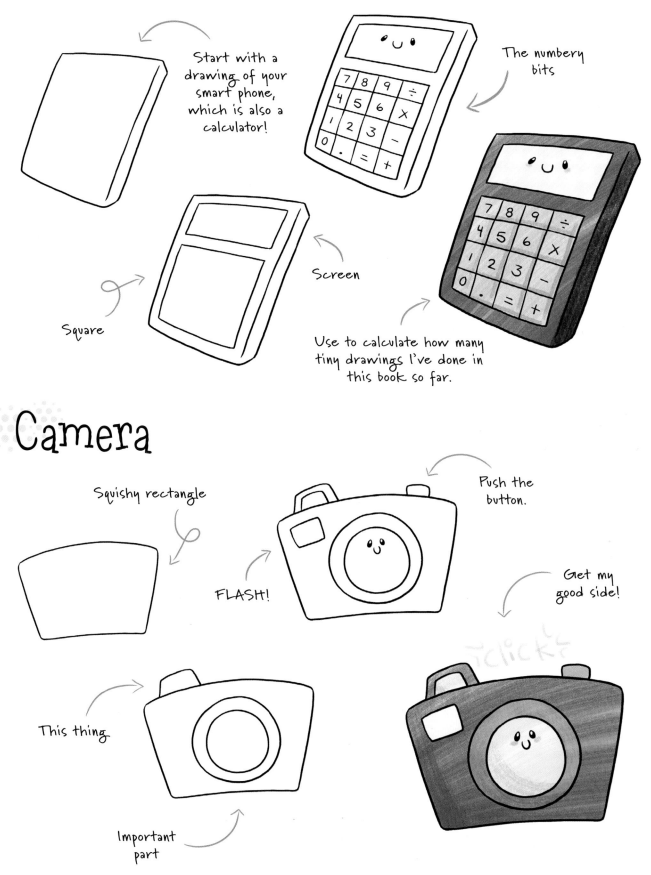

Start with a drawing of your smart phone, which is also a calculator!

The numbery bits

Screen

Square

Use to calculate how many tiny drawings I've done in this book so far.

Camera

Squishy rectangle

Push the button.

FLASH!

Get my good side!

This thing

click!

Important part

Television

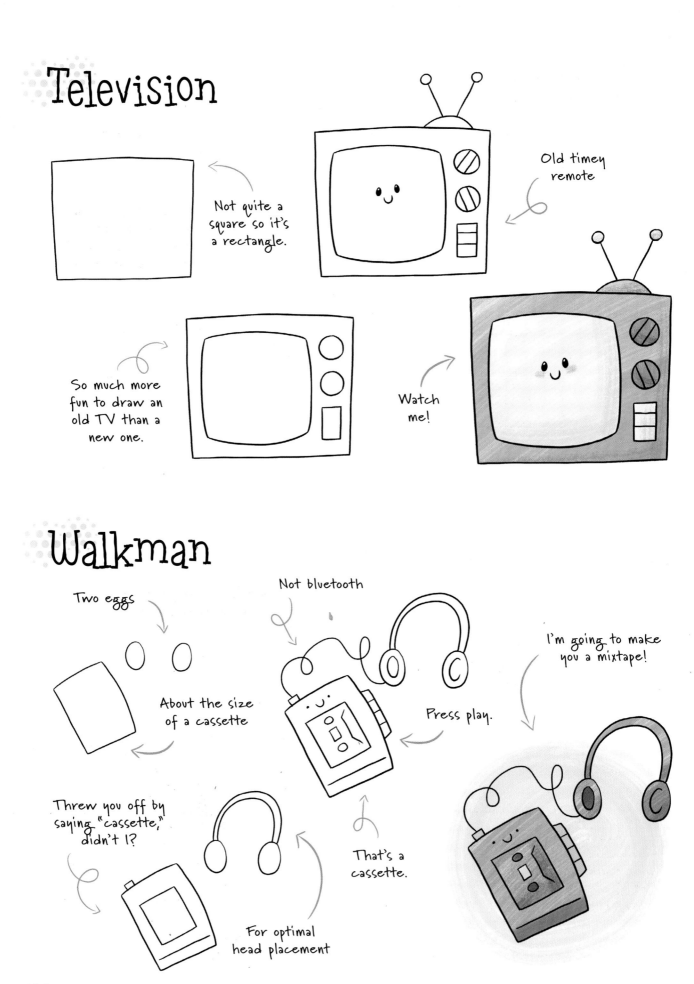

Not quite a square so it's a rectangle.

Old timey remote

So much more fun to draw an old TV than a new one.

Watch me!

Walkman

Two eggs

Not bluetooth

I'm going to make you a mixtape!

About the size of a cassette

Press play.

Threw you off by saying "cassette," didn't I?

That's a cassette.

For optimal head placement

Boombox

Rectangle

Necessary bits

Music comes out of here.

Find sappy song and stand outside loved one's window as you let the boombox speak for you.

Speakers

All this stuff

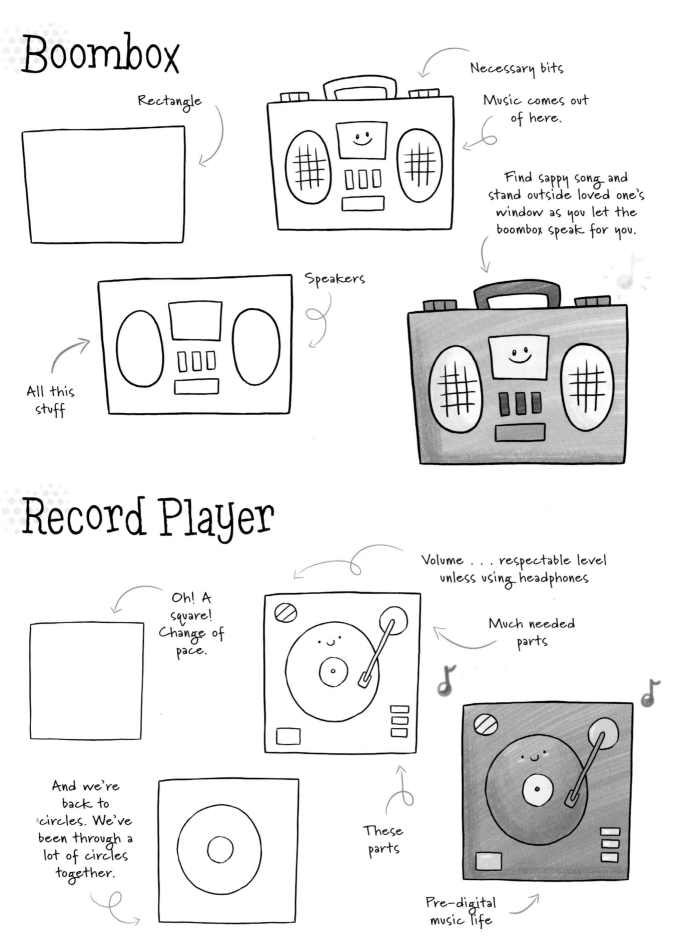

Record Player

Oh! A square! Change of pace.

Volume . . . respectable level unless using headphones

Much needed parts

And we're back to circles. We've been through a lot of circles together.

These parts

Pre-digital music life

Polaroid

Outline of your friend's uncomfortable futon

Do they even make these anymore?

All this stuff

Add pictures.

Telescope

Tapered paper towel roll

Star gazing for the win!

What telescopes are for

The big end

The small end

Tripod

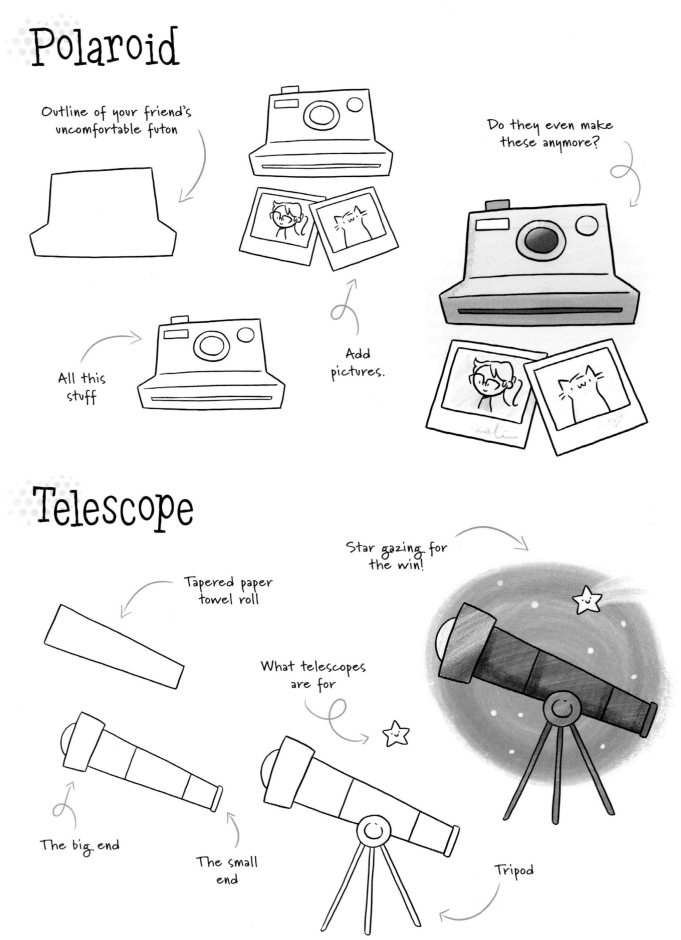

Lamp

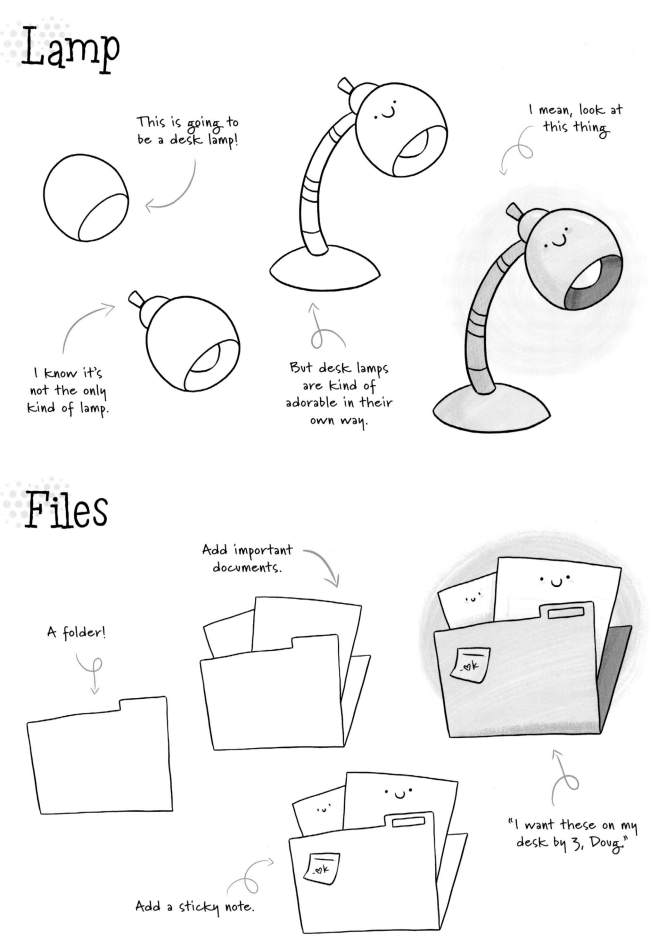

This is going to be a desk lamp!

I know it's not the only kind of lamp.

But desk lamps are kind of adorable in their own way.

I mean, look at this thing

Files

A folder!

Add important documents.

Add a sticky note.

"I want these on my desk by 3, Doug."

OK

Pot

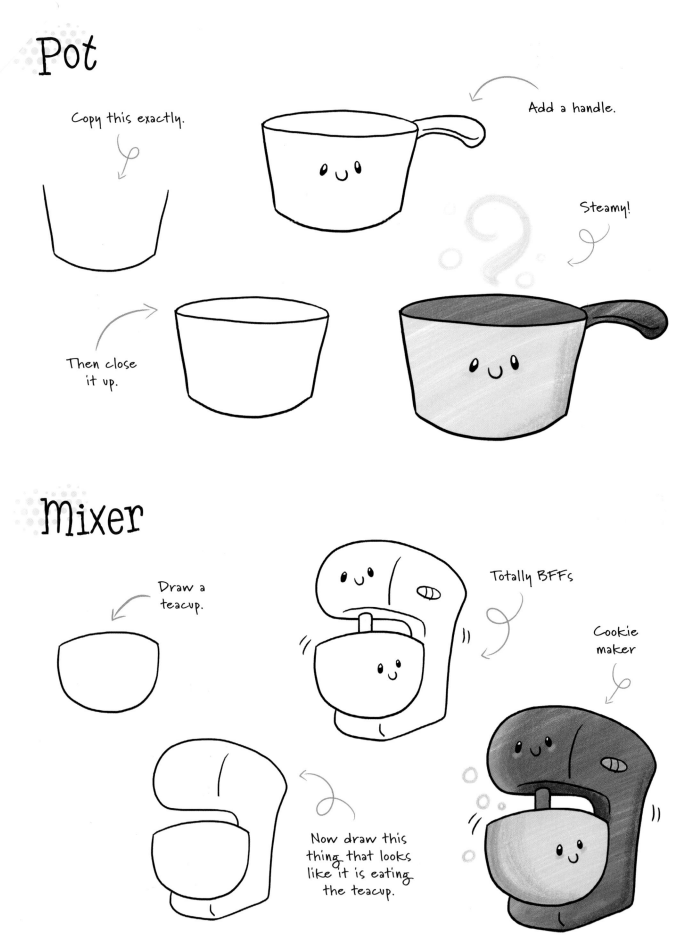

Copy this exactly.

Add a handle.

Steamy!

Then close it up.

Mixer

Draw a teacup.

Totally BFFs

Cookie maker

Now draw this thing that looks like it is eating the teacup.

Blender

There's that thumb shape again.

Blender nub

Buttons

Spill-proof

Sturdy base

Holdy bit

Smoothie time

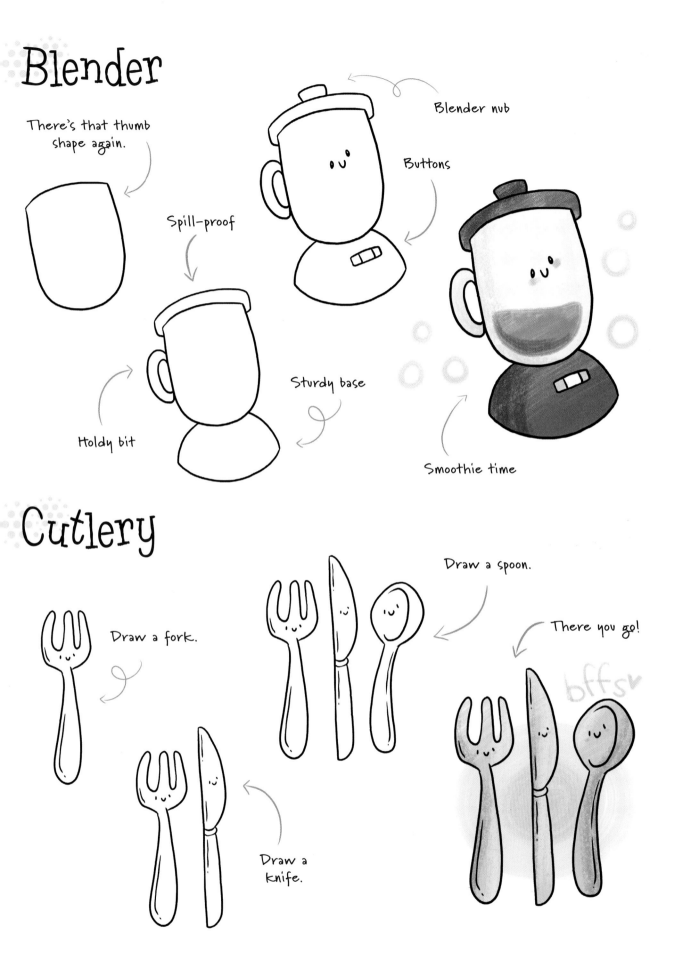

Cutlery

Draw a fork.

Draw a spoon.

There you go!

bffs

Draw a knife.

Toaster

A nice slice of crusty bread

The toast, so SO important

It took me until I was an adult to figure out toaster settings. I'm not proud.

Push down.

The base, so important

Refrigerator

Not a rectangle

Decorate

Bonus points for covering it in pictures of cats

INVITE

FIELD DAY

The openy bits

Up off the ground so every cat toy can end up under it

INVITE

FIELD DAY

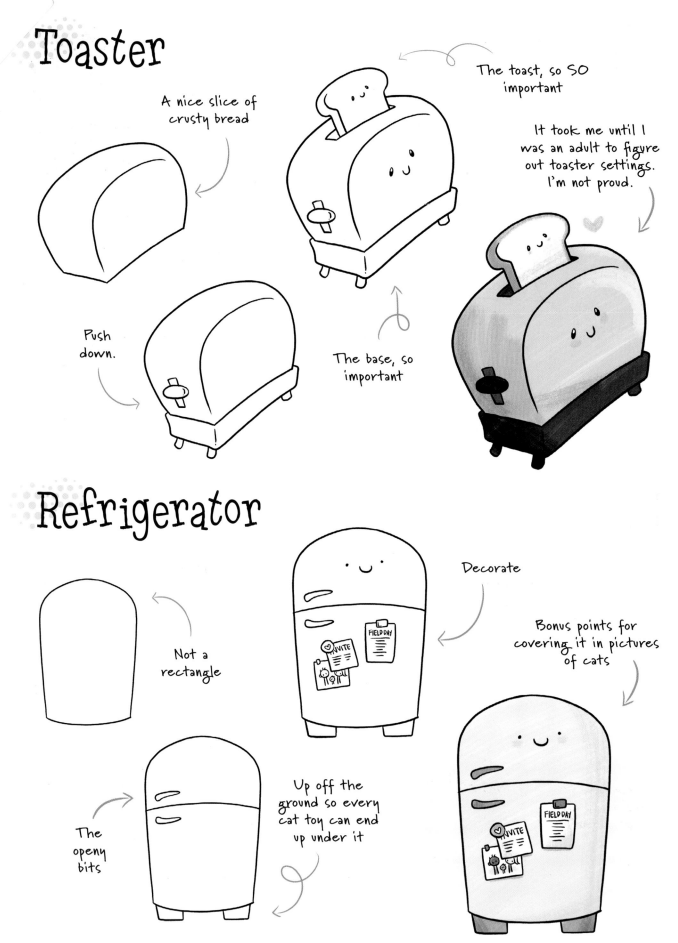

Washer

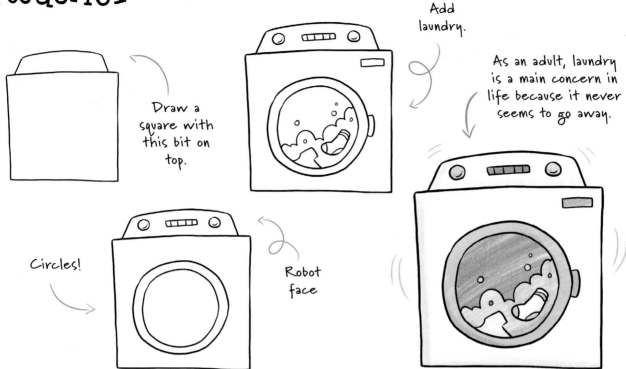

Draw a square with this bit on top.

Add laundry.

As an adult, laundry is a main concern in life because it never seems to go away.

Circles!

Robot face

Detergent

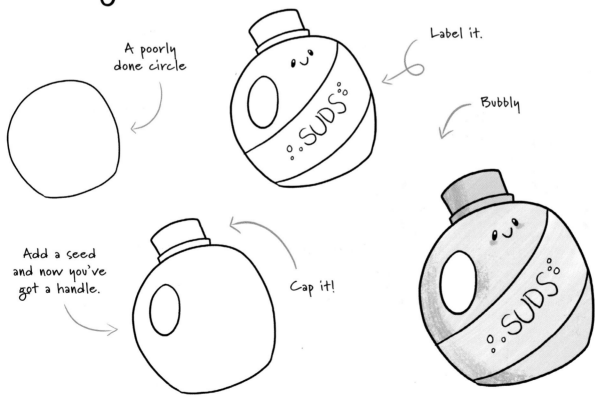

A poorly done circle

Label it.

Bubbly

Add a seed and now you've got a handle.

Cap it!

SUDS

Kite

Draw a diamond.

Kite nubs

Fluttery bit

Up to the highest height

Airplane

Draw an egg.

Other flying bit

More of this

This plane is pretty adorable. I'm all about it.

Propeller

Draw a smaller egg.

Flying bit

Tail?

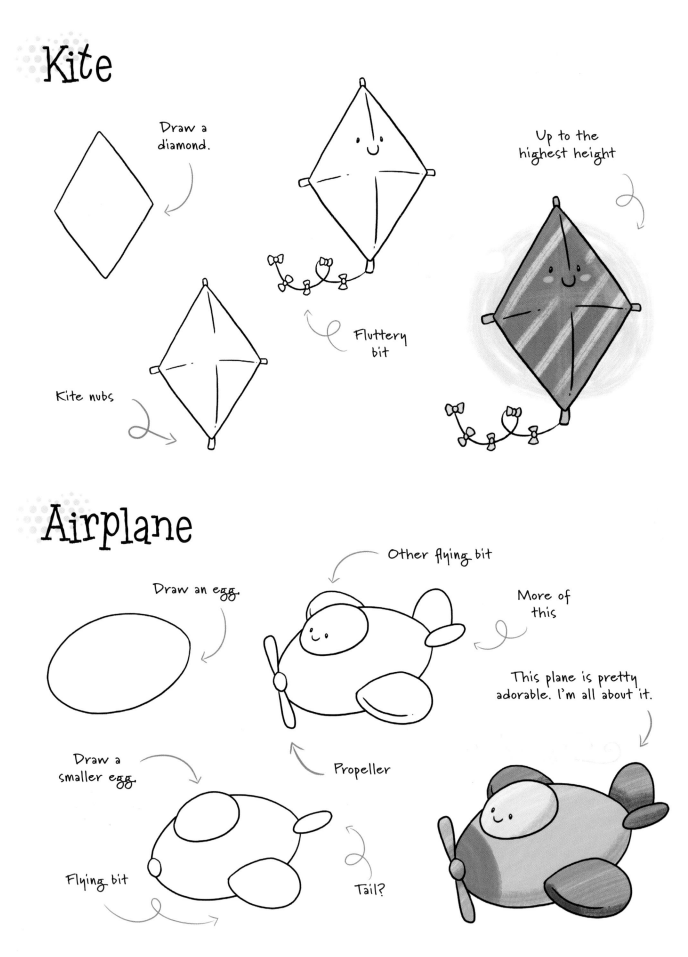

Mailbox

Tombstone

You have mail!

Ooh! Now it has a door.

Let's hope it's not all bills.

Now it's a loaf of bread

Bathtub

Incomplete bowl

Fancy faucet

Bubbles

Bubble baths are great! Highly recommend!

Slightly more complete bowl

Feet

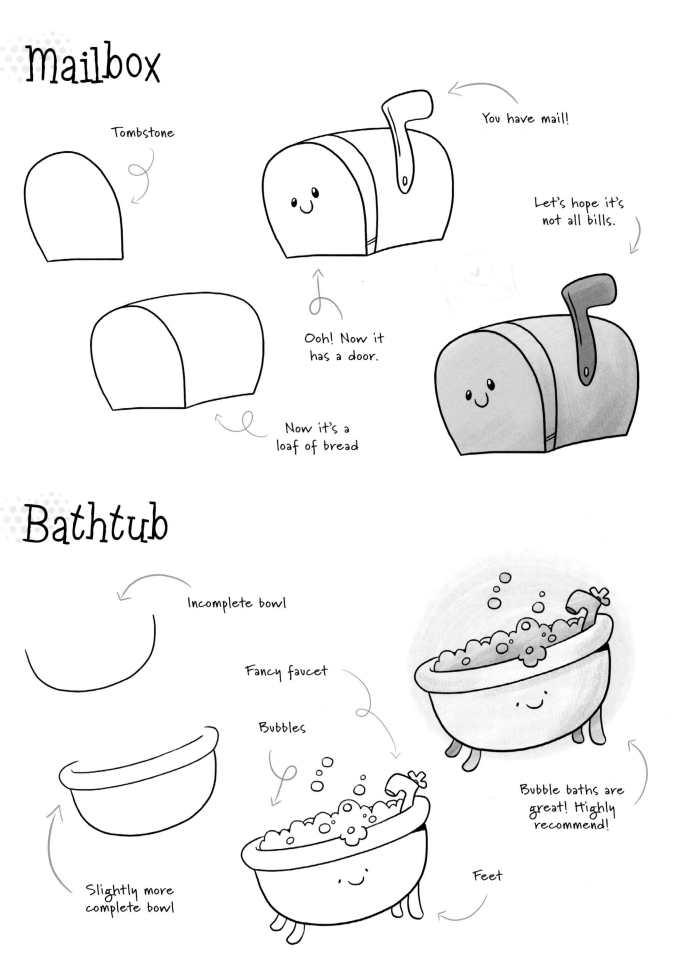

Coffee Maker

What is this, an award?

Add coffee pot. Coffee Pot is one of my dearest friends.

Percolate

Wait, is that decaf? GAH!

Luggage

Grip here to drag through airport.

I bet your ability to draw a weird shape like this has improved 23% because of this book.

Pro Tip

Buy the ones with 4 wheels. Trust me.

Zzzzzip

I put my socks in this bit.

Stuff to the brim with things you probably didn't need to take on your vacation with you . . . like 7 pairs of sandals.

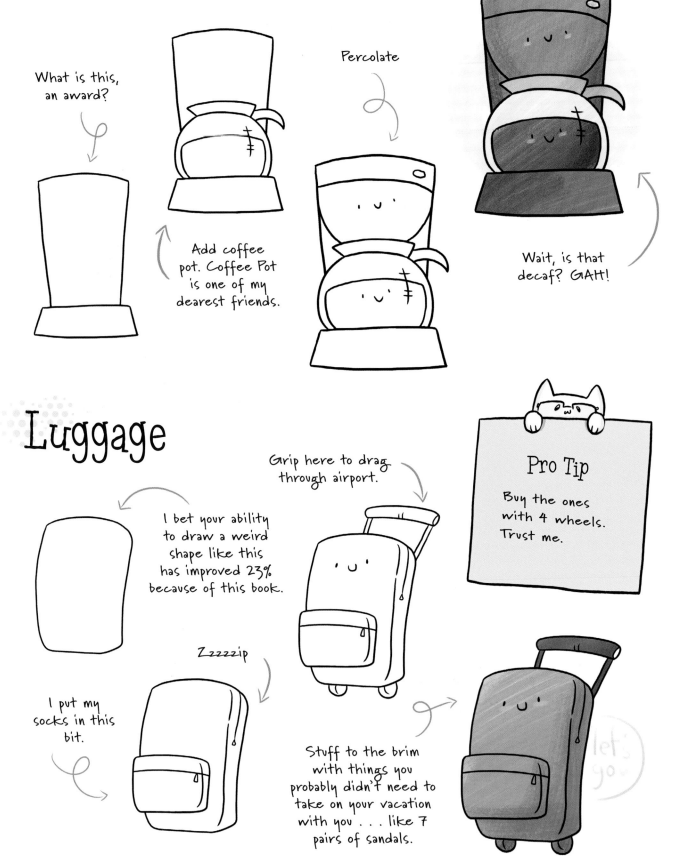

Hammer

AHA! I *did* put a hammer in!

Bet you thought I wouldn't put it in the book.

Look, a penny!

Actually, if you've been reading this book, you probably totally expected the hammer to be here.

...if only so I could end this one with "HAMMER TIME!"

um.

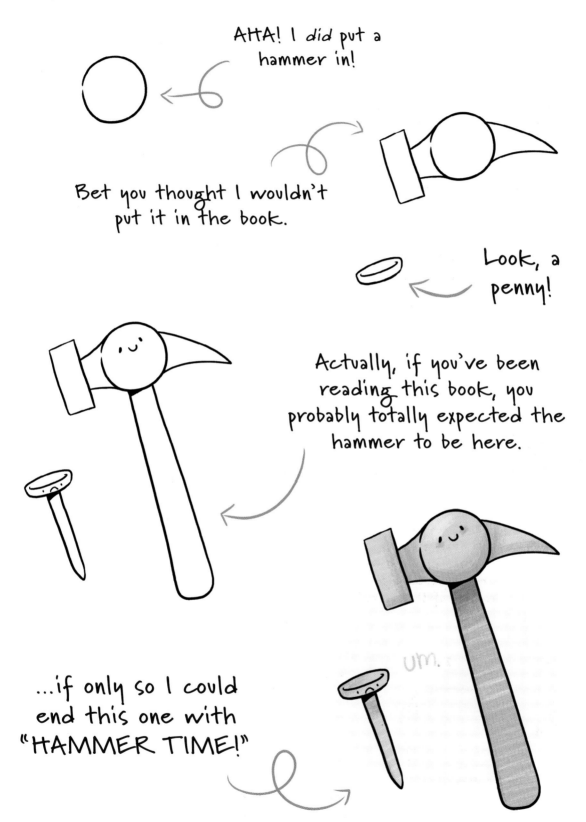

Closing

Hey all,

Thanks so much for going through this book with me. I really do hope that you had some fun drawing with me.

I guess, in closing, and I think you got this if you read any of the text in this book . . . don't take things too seriously. Did you mess up a few times? Good. Were you frustrated a couple times because a drawing didn't turn out right? Great. You'll learn from practice and the important thing is to have fun. I hope that you take anything you learned in this book, whether it's drawing a squashy shape or the word "nubbins" and run with it. Go forth and make some fun things.

xo, Katie

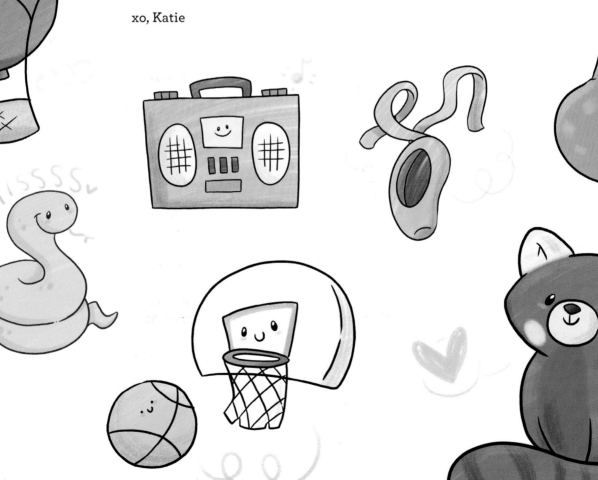

Index

fw
a content + ecommerce company

Other IMPACT Books are available from your favorite bookstore, art supply store or online supplier. Visit our website at fwmedia.com.

22 21 20 19 18 5 4 3 2

DISTRIBUTED IN THE U.K. AND EUROPE
BY F&W MEDIA INTERNATIONAL LTD
Pynes Hill Court, Pynes Hill, Rydon Lane, Exeter, EX2 5AZ,
United Kingdom
Tel: (+44) 1392 797680
E-mail: enquiries@fwmedia.com

ISBN 13: 978-1-4403-5230-0

Edited by Amy Jones
Production edited by Jennifer Zellner
Cover designed by Katie Cook
Designed by Jamie DeAnne
Production coordinated by Jennifer Bass

Dedication

This book is for Ryan.
He knows what he did.

Acknowledgments

I would like to thank my family because they have to put up with me on a daily basis. My husband is ever tolerant of me being a bit off my rocker and even encourages it.

My girls, Grayson and Harper, day after day they remind me why drawing is fun and weird and a pure joy. Teaching them and watching them grow into mini artists motivates me like nothing else to stay fun.

Also, my parents are the best. All other parents are just vying for second place at this point.

And thank you to Myrsini for having my back and all the folks at IMPACT who made this book possible. Everyone at IMPACT was a delight to work with. I owe you all the fruit baskets.

Metric Conversion Chart

TO CONVERT	TO	MULTIPLY BY
Inches	Centimeters	2.54
Centimeters	Inches	0.4
Feet	Centimeters	30.5
Centimeters	Feet	0.03
Yards	Meters	0.9
Meters	Yards	1.1

How to Draw Katie Cook

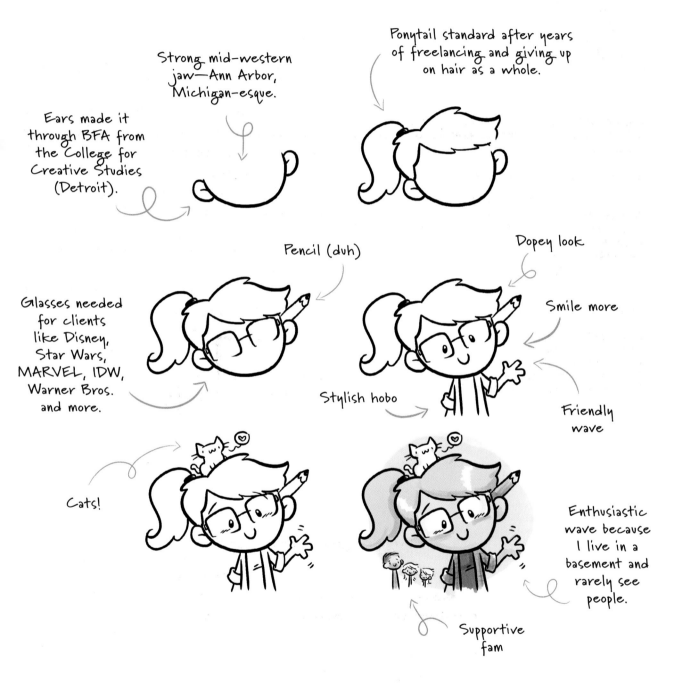

Strong mid-western jaw—Ann Arbor, Michigan-esque.

Ponytail standard after years of freelancing and giving up on hair as a whole.

Ears made it through BFA from the College for Creative Studies (Detroit).

Pencil (duh)

Dopey look

Smile more

Glasses needed for clients like Disney, Star Wars, MARVEL, IDW, Warner Bros. and more.

Stylish hobo

Friendly wave

Cats!

Enthusiastic wave because I live in a basement and rarely see people.

Supportive fam

FIND KATIE ONLINE AT KATIECANDRAW.COM

Ideas. Instruction. Inspiration.